PILGRIMAGE
TO THE END OF
THE WORLD

PILGRIMAGE
TO THE END OF
THE WORLD

The Road to Santiago de Compostela

CONRAD RUDOLPH

The University of Chicago Press
Chicago & London

CONRAD RUDOLPH is professor of medieval art and chair of the art history department at the University of California, Riverside. Apart from his life as a medievalist, he is an inveterate hiker.

The University of Chicago Press, Chicago 60637
The University of Chicago Press, Ltd., London
© 2004 by The University of Chicago
All rights reserved. Published 2004
Printed in the United States of America

13 12 11 10 09 08 3 4 5

ISBN: 0-226-73125-1 (cloth)
ISBN: 0-226-73127-8 (paper)

Library of Congress Cataloging-in-Publication Data

Rudolph, Conrad, 1951–
 Pilgrimage to the end of the world : the road to Santiago de
 Compostela / Conrad Rudolph.
 p. cm.
 ISBN 0-226-73125-1 (cloth : alk. paper) — ISBN 0-226-73127-8
 (pbk. : alk. paper)
 1. Spain, Northern—Description and travel. 2. Santiago de
 Compostela (Spain). 3. Christian pilgrims and pilgrimages—Spain—
 Santiago de Compostela. 4. Rudolph, Conrad, 1951– —Travel—
 Spain—Santiago de Compostela. I. Title.
 DP285.R83 2004
 263′.0424611—dc22

 2003022011

TO THE VOLUNTEERS

who work the hostels of the pilgrimage roads to

Santiago and those who run the pilgrims' organizations,

who help keep the pilgrimage alive

CONTENTS

PREFACE

The idea of doing the pilgrimage from Le Puy, in south-central France, to Santiago de Compostela, in northwestern Spain, first came to me after I read the twelfth-century *Pilgrim's Guide* and realized it was a medieval do-it-yourself manual that still worked. I didn't know then, ten years before I actually managed to set out, how little the pilgrimage had changed since its decline after the Reformation and the Age of Enlightenment. Simply assuming that it had died out completely, I thought I'd take the twelfth-century guide and, following one of the ancient routes it describes, wander from town to town, alone, like a vagrant. Eventually, I did take the old text with me, but only out of historical interest, for, as I quickly discovered, the pilgrimage to Santiago has undergone a remarkable renewal of interest in Europe and, to some extent, in the United States, and there is no shortage of modern guide books that follow the medieval routes. Although few people begin at Le Puy, one of the "classic" starting points in France, or even Roncesvalles, the ancient pilgrimage abbey in the middle of the Pyrenees that marks the beginning of the Spanish segment of the route, thousands do walk to Santiago every year, most from somewhere near

the minimum required distance (the last hundred kilometers, around sixty-three miles) to earn the Compostela, the certificate of completion of the pilgrimage that has been conferred since the thirteenth century.

This book, whose subject is the journey to Santiago, consists of four parts, each with a distinctly different aim, something that parallels the nature of the pilgrimage very closely.

Unlike most other accounts of the pilgrimage, the core of this book—the second chapter, "The Pilgrimage to Santiago and to the End of the World"—is not a day-by-day description of the journey but a series of reflections on a number of different levels of what is, ultimately, the internal experience for many. It attempts to evoke the texture of the pilgrimage, the impressions and feelings that many have had on it, and, to a certain extent, to bridge, however feebly, the chasm between modernity and this inherently premodern experience.

Because this book is meant to kindle the interest of a broad public, one not necessarily familiar with things medieval, it seemed best to bracket my account of the internal experience of the pilgrimage between two other parts. Even more than carrying a pack that's too heavy, it would be a mistake to do the pilgrimage without first learning something about it and understanding it a little. And so the opening bracket—the first chapter, "Pilgrimage in the Middle Ages"—provides the necessary historical basis from which to understand the pilgrimage. In it, I have tried to present the historical pilgrimage, as much as the medieval sources would allow, from the perspective of the experience of the medieval pilgrim.

The closing bracket consists of the third and fourth chapters. The third chapter—"Views of the Journey"—addresses what might be called the external experience of the pilgrimage through photographs of the country encountered along the way, including the towns, people, churches, and other ancient

sites that are such an important part of the pilgrimage. While it is not the purpose of these photographs to act as a catalog of the many famous places passed through, the illustrations do follow the itinerary of the Le Puy to Santiago pilgrimage from beginning to end. Taken in the dust of the trail, they are meant to contribute to the sense of the physical journey in the most general way: what the trail is really like.

The fourth chapter—"Doing the Pilgrimage"—might be called the reality of the road. It is practicality itself, born of experience: pretty much everything a person might need to know in order to take the first step on the pilgrimage road—and the second. If you find that any of the first three chapters of this book captures your imagination and you are thinking about doing the pilgrimage yourself, read this fourth chapter closely and take the jump! I doubt that anyone will fail who closely follows the advice given there.

⌒

It was widely believed in the Middle Ages that the pilgrimage road had its rewards. Whatever those rewards were for me, they would not have been possible without the support and encouragement of any number of people, most of whom never had the opportunity to take that road but who certainly helped me along it, each in his or her own way.

Chief among these are my wife, Roberta, and daughter, Anna, who gracefully accepted the idea of my making the pilgrimage and followed its progress from home, mountain range by mountain range.

Thanks must also go to Grace Barnes, an early supporter who instinctively sensed the special quality of this undertaking; to Bill Christian, Lothar von Falkenhausen, Nancy Frey, David Kunzle, Sharan E. Newman, Steven Ostrow, Marty Powers, and Kathleen Pyne, who critically read this text; to Sanda Agalidi,

Marina Belozerskaya, Pam Blackwell, Alan Castle, Faya Causey, Sara Chan, Vanessa Craig, Eduardo Douglas, Judson Emerick, Peter Fergusson, Françoise Forster-Hahn, Karen Genet, Piotr Gorecki, Avital Heyman, Ginger Hsü, Pierre Alain Mariaux, Madelyn Millen, Glen Olson, Ray and Eva Orbach, Deborah Rudolph, Kristin Sazama, Leo Schouest, Grady Spires, the late Harvey Stahl, Linda Stearns, Victoria Steele, Ivan Strenski, Frances Terpak, Raymond Van Dam, Bruce Whiteman, John Williams, Zhang Longxi, and the bright young German scholar I met at Leeds in 1998 and whose business card I lost; and, above all, to Eric Doud and, again, Lothar von Falkenhausen, who, upon hearing about this journey, immediately resolved to come along, giving up things in their professional lives that mattered in order to take this long, hard road.

Finally, writing a book is not at all the same thing as making one, and, for their help in that endeavor, I would like to express my sincere gratitude to a number of people. I am greatly indebted to my traveling companions Eric Doud and Lothar von Falkenhausen for the generous use of the photographs they took on our journey; and to James Austin, David Herwaldt, Alison Langmead, Claude Sintès, and the Office de Tourisme, Le Puy en Velay, for the use of their photographs. I continue to be obliged to Claire Clement for her special skills, upon which I depend so much, in helping to put together the maps and prepare the photographs that appear in this book. Very special thanks are reserved for the press readers, Jim D'Emilio and Therese Martin, without whose insight and generosity this book would be wanting. And, lastly, I would like to express my deep appreciation to Susan Bielstein, executive editor at the University of Chicago Press, for the special role she has played in the book's development and publication.

PILGRIMAGE IN THE
MIDDLE AGES

With the exception of warfare, pilgrimage to a holy site was the single greatest adventure a person could have in the Middle Ages. Pilgrims typically gave up their daily means of livelihood and cast their fate to the wind as they set out on the open and highly dangerous road for months, even years, at a time. During the eleventh and twelfth centuries, when the urge to undertake pilgrimage was at its strongest, the stream of travelers along the famous Camino de Santiago (the Way of Saint James) is said to have been as many as half a million people or more a year.

That particular pilgrimage, to Santiago de Compostela, the city where the remains of the apostle Saint James the Greater are said to repose, follows an often rugged route over the Pyrenees and across the fields and forest tracks of northern Spain. The pilgrimage to Santiago continues to be popular today, and people undertake it for various reasons. When I made the pilgrimage, some of my friends spent as much time as they could

visiting museums and churches of historical interest, no doubt wondering why I, an art historian, avoided like the plague (to use a period metaphor) all but those I literally ran right into. To me, the pilgrimage is not like everyday travel. It is not about seeing a museum or yet another beautifully restored medieval church. It is an experience of a different order. And to understand it, one needs some sense of its history: what the medieval pilgrim might have heard about and anticipated and what, in my view, fills the cultural gap for the modern pilgrim.

To begin, I should say a few words about medieval pilgrimage in general and about the pilgrimage to Santiago in particular. Pilgrimage was and is a spiritual exercise in the form of a journey to a place believed to be made holy by a sacred event, or that possesses the relics of a holy person or object. Sometimes, it is even a journey to visit a living holy person.

Medieval pilgrimage usually included an ascetic component. The pilgrim often endured suffering and deprivation as an important aspect of the spiritual exercise, although, as *The Canterbury Tales* makes only too clear, strict asceticism was hardly emulated by all who undertook a pilgrimage.

The roots of pilgrimage run deep and predate Christianity by many centuries. Pagan and Judaic cultures had long made it a practice to visit holy sites. In the Christian tradition, from the very first visits to the places of the death and burial of Christ, pilgrimage destinations multiplied to include the many graves of the Early Christian martyrs until there were literally thousands of sites—local, regional, and international—that a pilgrim could visit. Many evolved from the transference of relics from their original contexts (typically, relics would be removed from graves and moved to churches). But, of these many thousands, there were three major places that every medieval pilgrim must have greatly desired to see, and even to die at, believing that to do so would increase his or her chances of

attaining salvation: Jerusalem, of course, where Christ died and was buried; Rome, the site of the deaths and burials of many Early Christian martyrs, particularly Saints Peter and Paul; and Santiago de Compostela, believed to be the burial place of the apostle Saint James the Greater, the brother of Saint John the Evangelist.

Exactly why Santiago became such an important destination isn't entirely clear. Certainly, the town's claim to possess the complete body of one of the twelve apostles was unique in the West outside of Rome, something that allowed Christians living north of the Alps to identify with that most revered, but for them least attainable, aspect of the popular cult of relics, the Early Christian.

Still, the great success of the pilgrimage to Santiago seems to have resulted from a number of other factors as well, such as the exotic image of Spain held by northern Europeans, the distance (far enough to be a "strange land" but close enough not to be discouraging, as Jerusalem must have been to many), the fame of the Spanish crusades and the popular poems related to them (for example, *The Song of Roland*), and the vigorous efforts by the Cathedral of Santiago and the monasteries and churches along the way to promote the pilgrimage.

The historical evidence behind the belief that Saint James was buried at Santiago ranges from the fantastic to the contradictory to the obscure. Tradition (which was greatly embroidered over the centuries) held that James left Jerusalem after the death of Christ, hoping to evangelize Spain. He had little success, though, and returned to Jerusalem, where he was summarily beheaded by Herod Agrippa and his body left outside the city walls to be eaten by dogs. Under the cover of darkness, James's disciples spirited away his remains, secreting them in a miraculously provided boat. With neither rudder nor crew, the boat traveled of its own accord to the end of the then-

known world, or, more specifically, to Padrón, near Iria Flavia, the capital of Roman Galicia, in northwestern Spain.

After many trials and miraculous events, the disciples buried the body of James in an old Roman cemetery some distance away from Iria. There it remained, forgotten and undisturbed for almost eight hundred years, the cemetery having been abandoned and having reverted to a field. However, around 812, strange things began to happen in that field. A mysterious star appeared, and supernatural music was heard by a hermit named Pelayo, who lived nearby. Guided by these signs to the tomb of Saint James (Santiago in Spanish), Pelayo found the body and reported his discovery to the local bishop of Iria. News traveled fast. Soon, pilgrims began to arrive at the site of Saint James of the Field of the Star, Santiago de Compostela—"Compostela" deriving from the Latin *Campus Stellae* (*Campo de la Estrella* in Spanish), meaning the Field of the Star, or from *compostum*, meaning the cemetery, depending on whom you believe. A chapel was built over the site, and the bishop moved his episcopal seat to Santiago.

The rest, as they say, is history, the history of a phenomenon that had an extraordinary impact on western European culture. The pilgrimage to Santiago, at that time one of the farthest corners of Christian Europe, was instrumental in the reintegration of Christian Spain into the European community, the development of international trade, the internationalization of monumental architecture and sculpture, and the reconquest of Moorish Spain.

But the medieval pilgrim thought nothing of these things. To him or her, the importance of the pilgrimage to Santiago was more personal, although the reasons for undertaking it could vary wildly, just as they do now. One pilgrim might be required to make the pilgrimage in order to expiate some great crime, wearing nothing but a loincloth, an unusually harsh sentence

under the best of conditions. A murderer might perform it as a punishment with the murder weapon chained to his body for all to see, only being allowed to remove it upon reaching Santiago. Yet another might undertake the journey as a penance imposed for "heresy" (which we today might well call a simple difference of opinion on religious beliefs), being required to declare his repentance and orthodoxy to the priests of Santiago at the end of his journey.

However, it was far more common to make this long and arduous journey out of the desire for a miraculous cure (the old pilgrimage roads must have been choked with the sick and dying), in fulfillment of a vow, or simply to attain the spiritual benefits that came with pilgrimage to the relics of the great saint and his holy place. To the medieval pilgrim, in an age when a direct relationship with the divine was felt to be beyond the average person's capacity and worth, the pilgrimage was a way to address, persuade, and even experience the divine more immediately than was possible at home. Even the prayers said by a pilgrim for himself, his family, his friends, and those along the way who had asked the pilgrim to pray for them were popularly believed to carry more weight when said at a great holy place than at home or in the local church. At the same time, many were highly curious about the world around them—as we know from the rather common condemnation of those who made the pilgrimage for reasons of "curiosity."

Yet this great quest of the spiritual—or curious—person came at a cost. Despite the fact that pilgrims were by law and custom guaranteed safe and toll-free passage, the roads were very dangerous. According to the twelfth-century *Pilgrim's Guide* to Santiago, "For only a *nummus* [a couple of dollars, we would say today], a Navarrese or a Basque will kill a Frenchman if he can." The Navarrese and (more broadly) Basque parts of Spain were regions through which all northern pilgrims,

certainly all French, had to travel on their way to Santiago. On some parts of the road, local thugs might demand tolls from pilgrims, severely beating those too poor or too foolish to pay. On others, boatmen might charge a fee to ferry pilgrims across a river only to kill them midstream and take their few, miserable possessions.

And the pilgrims themselves could be a pretty tough bunch: there were so many stabbings of pilgrims by pilgrims in the cathedral of Santiago (probably brought on by heavy drinking during feast days) that normal church functions were regularly interrupted because of the constant need to reconsecrate the church each time blood was shed within it, something that caused one medieval pope to grant Santiago the special privilege of an unusually brief reconsecration blessing.

Such great dangers, however, did little to dampen an almost unbridled enthusiasm for the pilgrimage, for the rewards were more than worth the risks to all who chose to undertake the journey—or, at any rate, to those who didn't turn back. Nor did the arguments of theologians against pilgrimage carry much weight. Church fathers such as Augustine reasoned that pilgrimage was pointless, at least in theory, since the holy could not be localized in any given place. The people, however, knew better, and one medieval source captures something of their fervor in its description of a pilgrimage in the making: how the roads and fields around the new holy place were so thronged with converging pilgrims that the town appeared to be under siege, how local merchants strained to provide enough food for the advancing hordes, and how it took several men laboring all day long to gather up only the gifts of coins and silver thread—to say nothing of the horses, oxen, cows, pigs, sheep, linen, wax, bread, and cheeses that were "placed upon the altar" as well.

But a regional upstart like this could offer nothing compared

with the amazing spectacles of the convergence of peoples from all over the Christian world at one of the great, long-established holy places. At Santiago, a twelfth-century eye-witness describes an endless flood of

the poor, the fortunate, the barbarous, knights, foot soldiers, lords, the blind, those missing hands, nobles, the illustrious, heroes, princes, bishops, abbots — some barefoot, some without means, some bound with iron chains in penance. Some, such as the Greeks, hold the image of the cross in their hands; others distribute their possessions to the poor; some carry iron or lead for the construction of the basilica of the Apostle; and others, still, who have been liberated by the Apostle from the prisons of the wicked, bearing their iron shackles and manacles upon their shoulders, perform penance and weep for their sins. This is a chosen people, a holy people, the people of God, the chosen of the nations.

The same source tells how, at the night-long vigil of a great feast day at Santiago, the Germans occupied one side of the high altar, the French another, and the Italians yet another, all singing independently and in their own languages, playing an incredible assortment of "cithers, lyres, drums, flutes, pan-pipes, trumpets, harps, viols, British or French zithers, and psalteries" (which they must have carried with great labor along the trail), while other pilgrims prayed, read psalms, wept for their sins, or sought out the blind in order to give alms. The sick and those with mental problems were a major presence at the most popular holy places, sometimes waiting many months for a cure—perhaps in the transepts of the great churches—their coughs, ravings, and putrefying flesh as much a part of the pilgrimage experience as the constant masses, unending processions, and smell of incense.

The great feast days inundated the churches with hordes of pilgrims, merchants, and beggars and were characterized by

vast, unruly crowds often completely out of control. The abbot of one renowned pilgrimage monastery tells how the press in his church would become so great from those struggling to get out of the building slamming head on into those fighting just as hard to get in that absolute gridlock would take hold. "No one could move a foot." A woman might be so immobilized by the crush of the men around her that all she could do was "stand like a marble statue" and, "as a last resort," scream. Sometimes, women who fainted from the ordeal would remain completely upright, as if standing, held up by the press of the mob, while others ran in a frenzy to the front of the church on the heads and shoulders of the crowd "as if on a pavement," and the monks at the front of the church had to break open the windows in order to escape, taking their precious relics with them.

The relic was the focus of all this. The most common consisted of the physical remains of a holy person, anything from a head or an arm to a tooth or a bit of bone. If a place were truly fortunate, it might possess the entire body of some great saint. Often described as *pignores*—a word that doesn't translate well into either modern English or modern ways of thinking—these relics were seen as "pledges," assurances left behind to common mortals that the holy person would return from God to the place where his or her relics were kept to reclaim his body at the general resurrection at the end of time. Those faithful who were rich enough paid dearly to be buried near the relics of a miracle-working saint in the hope of being first in line when he was selecting those few he would take along with him to heaven. For those who had no hope of such breathtaking privilege, it would have to suffice to partake of the spiritual powers of the saint that radiated from the tomb, powers they hoped to merit by having undergone the rigors of pilgrimage.

However, the practice of claiming to possess the body parts of people who, often enough, had died a thousand years earlier

could cause problems—as when two prominent churches each claimed to possess the entire head of John the Baptist, leading one contemporary critic to ask, sarcastically, if the illustrious saint were bicephalous. More worrisome was the claim by another church to possess no less than the foreskin of Christ himself, something that raised weighty theological questions about the nature of Christ and his resurrection, as did the highly prized relic of his umbilical cord.

Almost as popular were those relics that were not body parts but objects related in one way or another to a particular holy person or sacred event. The greatest of these is the renowned True Cross, which was miraculously replenished—as was the treasury of the church that possessed a relic of it—whenever a small piece was broken off (for example, to sell for veneration elsewhere). The city of Rome was a veritable Disneyland of such relics, possessing relics that imaginatively wended their way from the Old Testament through the New, an astonishing array of objects from the original Ten Commandments and manna from the wanderings of the Hebrews in the desert, to John the Baptist's hair shirt, loaves and fish from those that fed the five thousand, the table of the Last Supper, the stairs upon which Christ walked to his condemnation by Pontius Pilate, and the veil with which Veronica dried his face when he carried the cross. Churches elsewhere possessed equally great relics, including milk from the Virgin's breast, tunics of the Virgin (including the one in which she gave birth to Christ), the scourges used to flagellate Christ, thorns from the crown of thorns, nails from the crucifixion (one of which was worked into a royal crown), the spear that had pierced Christ's side, and—the only one of these to retain its vast renown into modern times—the shroud in which Christ had been buried.

Less spectacular but no less fascinating were the many minor relics, now almost completely forgotten: an ancient box of dirt

and rocks collected from different sites in the Holy Land, the holy table upon which a great saint ate his last meal, or the plow of a local holy man, placed on the altar of some now anonymous church. One of the most astonishing is the Fever Stone of Le Puy, a prehistoric menhir (a monolith, originally standing) that, after the Virgin appeared on it, miraculously cured many who lay upon its surface (as I did), functioning in the same way that many pre-Christian sacred wells continued to function at a surprising number of Christian pilgrimage sites.

Medieval society was one in which the sacred was so fundamental to everyday life that it coexisted quite easily alongside the profane, something that only increased the already rich cultural experience of the pilgrimage. And so the curious pilgrim, if he or she traveled long enough and far enough, might see—alongside the relics that were the objective of the journey—stuffed crocodiles, meteorites, unicorn horns, griffon claws, elephant tusks, and even the entire skeleton of an elephant that had been presented to Charlemagne by the caliph of Baghdad.

The curious pilgrim would also have seen heaps of votive offerings in the shapes of eyes, hands, legs, or whatever part of the body the saint was asked to cure—hanging next to images of a house saved from fire, a beloved lost hunting falcon, or the anchor of a ship rescued from a storm at sea. But perhaps the most striking votive offerings were the prisoners' chains, broken asunder, that hung throughout many of the churches of the pilgrimage routes. One church was said in *The Pilgrim's Guide* to have "thousands upon thousands" of these chains brought by those who had been freed by the saint from both local conflict and the great wars. Another was said to have such a mass of offerings that it was almost impossible for the eager crowds to circulate.

The relics themselves were rarely shown to pilgrims except

on great feast days, and sometimes not even then. Instead, what the pilgrim usually saw when visiting the famous holy places were reliquaries of often incredible lavishness and design, sometimes twenty feet or more in height, surpassing the scale of a small house. Some were shaped like the arm or foot or head within. Often they were made of solid gold and covered with precious jewels and ancient cameos or elaborate imagery that told the tale of the saint. At times, the reliquary might be fashioned in the full image of the saint, such as the one an eleventh-century eyewitness characterized as a pagan "idol" and whose veneration by the country folk (who believed they could see its face respond to their requests) he compared to "the rites of the old cult of the gods," or the one he described as so densely surrounded by desperate petitioners lying on the floor in worship that he himself could not even get down to pray.

The power of these relics must have been overwhelming to many pilgrims. Some might crawl into the very tombs of the saints—not in with the actual remains but into areas specifically designed to be entered by supplicating pilgrims. Others ate the dust or mortar of saints' tombs, believing it to have miraculous qualities, just as they believed the wax or wicks of candles burned at the tomb of a great saint had special powers. Some drank the water used to wash the tombs, the wine used to wash the skull of a revered saint, the water in which the mummified hand of a saint had been dipped, or even the water in which living holy men had washed themselves. One great prelate who wouldn't open his mouth after biting off a knuckle bone from a saint's skeletal hand he had been allowed to kiss was permitted to keep it: you just can't buy publicity like that, something the old monks understood very well. With public reactions like these, it's no wonder that so many churches went to such great lengths to acquire powerful relics, at times even stealing them and openly admitting it.

And the personal presence of a hallowed saint might be felt to be so strong that pen and parchment would be left on his tomb in case he felt moved to write down his response to a particular question. By contrast, the relics of a less-responsive saint might be "humiliated" by being placed on the ground and covered with thorns, or even threatened with flogging and thrown down a well. Could things get any stranger? Yes, they could. One local pilgrimage, which Church authorities tried (unsuccessfully) to bring to an end, was to the relics of a dog who became revered as a saint, something that makes you wonder just what gifts medieval pilgrims might have brought to please such a saint.

The great draw in all this was the miraculous. Miracles might range from the most dramatic to the most mundane, from raising the dead (including animals) to finding lost objects. Some saints specialized in particular miracles: one was famous for curing leprosy, another for alleviating holy fire (a horrible disease caused by eating bread tainted with ergot, a fungus), and another for freeing prisoners, be it from the bonds of Christian or Muslim. But the vast majority of miracles involved the restoration of health, both physical and spiritual. Aside from such classic miracles as the restoration of sight and hearing, lesser miracles operated like a medieval version of our own modern health-care system. The great pilgrimage saints deigned to treat everything from kidney stones to toothaches and even turned their attention to such ailments as baldness and impotence, complaints now addressed by "the miracle of modern medicine" through the good offices of Saints Rogaine and Viagra.

A person like me, who doesn't believe in miracles in any form, struggles to come to an understanding of just what took place in the Middle Ages at these holy sites. But, although there are any number of possible explanations, in the end I don't have

to account for the miraculous in the Middle Ages, I only have to recognize that the miraculous was real to the people of the time and that the pilgrimage churches were places where they believed miracles regularly occurred. The miraculous is not only a fundamental part of the spiritual history of the pilgrimage, it is also part of its physical context: within the space circumscribed by the walls of all the major pilgrimage churches, hundreds, even thousands, of miracles, however understood, took place for pilgrims in the past.

Pilgrims were actually fought over, the legal right to care for them disputed, and the enormous profits from the pilgrimage trade greatly sought. Pilgrims were sometimes told that if they died on the road with money in their pockets they would surely go to hell. Celebrated pilgrimage churches sometimes conducted international fund-raising projects, sending their relics on tour complete with experienced fund-raisers (preachers) who knew how to work a crowd. And even the saints themselves might demand lavish gifts: the girl-saint Foi, through whose holy place at Conques the Le Puy—Santiago pilgrim passes, was known to demand golden rings and bracelets from her female supplicants—severely punishing those who were slow to comply.

But many clerics were morally opposed to the financial aspect of the pilgrimage, whose potential for abuse always lay just beneath the surface of traditional religious practice and popular spirituality, accusing some churches of investing in the pilgrimage for the purpose of financial gain. And, although this frequently may have been true, many churches expended enormous sums for the care of pilgrims. At the same time, lay people along the way often gave charity to pilgrims, asking in return only a prayer for themselves at the end of the pilgrim's journey. And the pilgrims themselves, as part of the penitential nature of their undertaking, were expected to give generously to

the churches and to the swarms of beggars who besieged every great holy place.

All of what I have been describing took place amid a setting of thousands of candles and a virtual paradise of glittering art—an effect that was consciously sought. Indeed, the visual power of the holy place was meant to be all but destabilizing: the author of a twelfth-century art manual describes the desired response of a visitor to a fully decorated church as one in which "the human eye is unable to decide on which work to fix its gaze first." And it was meant to be transforming: as a medieval author says about visiting the church of Santiago, "Whoever goes in sad leaves happy."

But there was more to the deployment of art at pilgrimage churches than just this. One medieval source describes how a wealthy woman had traveled far to one church, caught up in the earliest stages of a pilgrimage mania prompted by the arrival of relics of two saints from Rome and bringing with her a wagonload of rich gifts:

When she got near, she actually ran ahead of the wagon. However, when she saw that their tomb did not glitter with gold and silver, she looked down on the place and ridiculed it, as dull and irreligious minds usually do. Immediately turning around to meet her party, she ordered those who had come with her to return, saying that there was nothing holy contained there.

The premise of the pilgrimage was that the holy could be localized, and the crowds expected its presence to be palpable at the great holy sites. Art was, in part, used to fulfill the expectations of the crowd, and even came to be equated with the holiness attributed to the relics themselves. Ultimately, pilgrimage art was as much a necessity for these holy places as were the very relics. This aesthetics of holiness could be seen in both negative and positive terms. As one articulate twelfth-

century critic put it, "The very sight of these costly but wonderful illusions inflames men more to give than to pray. . . . Eyes are fixed on relics covered with gold and purses are opened. The thoroughly beautiful image of some male or female saint is exhibited and that saint is believed to be the more holy the more highly colored the image is." Others saw it differently: as the author of *The Pilgrim's Guide* says about a visit to one of the great southern French pilgrimage churches, "How beautiful and [spiritually] valuable it is to visit the tomb of Saint Giles!"

⌒

This, then, was the cultural atmosphere of the medieval pilgrimage. It was one of faith and of manipulation of that faith. It was one of desire and, at times, of compulsion. But whatever the inherent contradictions, to the modern mind the pilgrimage is certainly one of the most appealing aspects of medieval civilization. The churches of every level that once attracted so many from so far have now been stripped of their vast programs of art and votive offerings, programs that were both the setting and the visual mainstay of the hundreds, even thousands, of wildly popular relic cults that were the focus of all this. It is the challenge of the modern pilgrim to mentally reconstruct the dynamic of the medieval pilgrimage place, the life that went on in these churches, large and small.

Though the pilgrimage to Santiago began to decline toward the end of the Middle Ages, it never died out. Pilgrims never stopped making the arduous journey over the Pyrenees and across the treeless and sun-scorched plains of northern Spain. The daunting routes given in the twelfth-century *Pilgrim's Guide* are the same ones followed with such difficulty today. The ancient stopping places listed there are still visited by an unending flow of pilgrims, now a trickle, now a flood. The

pilgrimage continues to be done for many of the same reasons, with modern pilgrims still looking for their own little miracles, though these may be nothing more than antidotes for the stress and strain of modern life. And the curious, each for his or her own reason, still take part.

THE PILGRIMAGE ᵀᴼ SANTIAGO AND ᵀᴼ THE END OF THE WORLD

The fingerless beggar put his hand on my shoulder and—pulling me into the deeply pungent, musky aura that surrounded him of a body washed with water but not soap—told me that the skull the half-naked woman held in her lap was that of her lover. Her husband had cut it off, and she was forced to kiss it every day. I was captivated not only by the overpowering force of conviction with which he said this, but by the fact that this popular but mistaken explanation of one of the most enigmatic sculptures on the great twelfth-century Spanish cathedral of Santiago de Compostela was exactly the same one given in the earliest travel guide of Western culture, *The Pilgrim's Guide,* written for pilgrims to Santiago around the time that the cathedral had been built and the woman carved.

The pilgrimage to Santiago was one of the great cultural undertakings of the Middle Ages and perhaps the most extraordinary adventure a person could have. Traveling to the supposed tomb of Saint James the Apostle, pilgrims from all over Europe for centuries suffered the certain dangers and grueling rigors of the road. They did this for both religious and nonreligious reasons—the latter practice sometimes being called *curiositas,* "curiosity," in the Middle Ages. I, too, was among the "curious" when I undertook the pilgrimage on foot from Le Puy to Santiago in the spring and summer of 1996, a journey of two and a half months and a thousand miles.

How long is two and a half months? Long enough to trick you into the strange feeling that the even stranger journey you're on is normal, everyday life. How far is a thousand miles? Far enough for the staff you carry to fight off the almost daily dog attacks to wear down a full six inches, and for your boots to need reheeling—twice. Making the journey with two friends who each accompanied me for different parts of the way—Eric Doud, an architect, and Lothar von Falkenhausen, a professor of Chinese anthropology—I have never had my curiosity so indulged.

Grabbing me by the elbow and yanking me, the beggar led me to the top of the monumental stairway above the Renaissance plaza we were facing, the better to tell me about the baroque fountain there and the inscriptions—he knew every one—on the side of the stately treasury. Both of us were ragged. And both of us were limping: he, I assume, from the same indifferent twist of fate that had left him fingerless, and I, from "curiosity." I always limped now after keeping still for more than a minute or two. It had become so bad that when I got up from dinner in a restaurant, I was always afraid the other guests

would think I was drunk, having walked in steadily and stumbled out like a sailor on shore leave. Distinct from this, I had lost feeling in most of my toes, the soles and sides of my feet, and one thigh. My feet had been beaten into submission, to the point that the nerve endings gave up and didn't want to live anymore. They simply turned themselves off, accompanied by four toenails that were pounded off.

I hadn't expected this. I had begun the pilgrimage with calluses on my feet that a Marine would be proud of, the result of long, hard training in the semi-desert of southern California. The trail, however, was as tough as my calluses, and I got blisters *under* the calluses, where they couldn't be pierced, an excruciating experience that would go on and on until the next full day of hiking in the rain, when the whole thing would explode into an unrecognizable mass of overlapping layers of shredded epidermis and revealed blister upon revealed blister, like so many strata in an archaeological site, penetrating to depths I had thought impossible before. But I couldn't really complain: a couple of hours' walking left me surprisingly numb to most of the pain.

Of more concern was the toll the pilgrimage was taking on my body. Despite the fact that I ate almost twice as much while on the pilgrimage as I do at home, I couldn't eat enough to maintain regular body weight. At home, if I walked fifteen to twenty miles a day for five days—not a small hike—I'd drive back to my house, rest, and be a little stiff, maybe, but more or less fully recovered the next day. On the pilgrimage, when I had walked five days out of Le Puy, I still had only slightly less than two and a half months to go. But even more, the average day on the pilgrimage is physically harder than the hardest day in the average person's life. Even with the best planning, carrying a pack is the equivalent of lugging a four-year-old child around on your back—uphill, downhill, in the sun, in the rain,

through the mud, over unbelievably rocky and uneven trails, all day long, every day, sometimes for as long as eleven hours. You get tougher, but the pack doesn't get any lighter.

Still, the enormous exertion of the trails *was* good for sleeping. So good, in fact, that, in my normal, daily state of near exhaustion, I actually slept through a full-scale riot complete with molotov cocktails and rubber bullets centered on the twelfth-century pilgrims' hostel where I was staying in Pamplona—a Basque separatist riot that took place right outside my window and that was described as looking like a "war" by one of the lighter sleepers (he hadn't been on the road very long). But it was all worth it, every wincing movement, every lost nerve ending, every drop of sweat, every meal of bread and water.

For one thing, the scenery was astounding. The pilgrimage, for me, began in Le Puy, in the heart of the Massif Central. The word *puy* in French means a volcanic cone or, more precisely, the remaining inner stone core of a volcano after the surrounding earth of the cone has eroded away. The town itself, the result of thousands of years of habitation, is dramatically situated on several of these cores, one of them crowned by one of the greatest of the surviving Romanesque cathedrals. But far more astonishing is the nearby chapel of Saint-Michel d'Aiguilhe, which sits alone atop a volcanic core so tall and so narrow—the name, in fact, means Saint Michael of the Needle—that it's like something out of a dream: you stare, you take it in, you understand on a literal level, but, ultimately, the very building and its physical context convey a spiritual intensity so extreme that it's completely irreconcilable with the world that surrounds it, in which it exists.

The country I passed through during the week or two after I left Le Puy was entirely different, though in its own way no less intense. Despite having made many long trips to France in the past, I was completely unprepared for the stunning beauty

of a journey on foot through the Lozère, that part of the Massif Central through which the dazed pilgrim wanders on his way to the Pyrenees. A country that's both stark and beautiful, it has a stark beauty of green high-plateaus; of ever so clean, rain-washed and wind-scoured granite boulders that stick out of the grass like the tip of some giant whale just barely surfacing for air; of small, scattered herds of sheep and cows that seem as swallowed up in the bright, intense emptiness of the place as the alien pilgrim (I saw no other people here at all), a rarefied atmosphere that's like nothing so much as a photograph taken in outer space; of endless, ancient, mortarless walls of granite—often double walls, granite alleys for driving the herds—touched with lichen as rough as the stone itself; and of very little else but the painfully brilliant sky, a wind that was virtually a presence, and an endless variety of amazingly delicate wildflowers. Only the occasional farmhouse is seen, centuries old, of granite, its slate roofing tiles covered with moss and lichen, now abandoned, blending with the landscape, seemingly merging with and growing out of the landscape, made of the landscape, and some, eventually, returning to the landscape with a cyclical, almost mythological logic to their existence.

But every day was different. The land was never the same, even at the premodern pace at which we traveled. Slowly, as the earth changed, its use changed with it, eventually becoming more overtly productive and more densely populated. With people, the building types and materials—always from the earth, never man-made—changed in the same way that the brush, trees, and flowers did, only to revert to the stunningly wild and sparsely populated regions of the Pyrenees and Spain that we were to journey through for so long, occasionally fitted out with a town or, every week or two, a small city.

It could also be a magical landscape, as when we ascended

the Pyrenees in heavy fog, following the old Roman road, the one that Caesar, Charlemagne, Napoleon, and so many others had taken. At one point, it became all but vertical, the modern road branching off, following a different, lower route, more accessible to modern means of transportation. Eventually, we climbed above the fog to see the nearby mountain peaks standing out like islands in a sea of cloud, like a Japanese painting of the Inland Sea, with hundreds of startlingly white and shaggy sheep wandering along the green slopes, bleached-white sheep skulls strewn about in the manicured grass, and scores of golden vultures huddled in a group on a surreal rock formation overlooking the Pass of Roncesvalles, slowly, silently, and one by one flying off into the enveloping veil of fog as we came closer to stare in near disbelief. Or, further on, in the mountains of northwestern Spain, it was almost as if a spell had been cast, as we wandered in the early dawn light along the ridge of a mountain range higher than our passage through the Pyrenees, with a dry—still cool but getting warm—electric wind rustling every leaf and blade of grass, with the sun sparkling off the first ten thousand that met our eyes like a living version of some late Van Gogh landscape, and heard—but never saw the source— the sound of sheepbells tinkling in a way that was almost magical, timeless, coming from behind the writhing vegetation and seeming like an ancient wind chime that was consummately attuned to the setting. Or there was the night walk I took alone in France down a steep river valley lined with sheer stone cliff faces to catch a glimpse of the towers of some long-forgotten medieval monastery, everything silver in the full moon. Or there was the rest in a hot wind in Spain—it's etched into my memory: listening to the rustling of the leaves of the poplar trees competing with the bubbling water of a cold, clear mountain stream in which bright red cherries had been dropped by birds feeding in the trees that overhung the stream, the cherries shin-

ing with a magnified brightness from the water, brighter than those that hung on the trees that the birds were still fluttering around, squawking, chirping, playing, fighting. Or, leaving a Spanish monastery in which we had one of our most memorable stays, Samos, it was almost otherworldly to see the bright white of a small waterfall shine out of the not-yet-lightening predawn darkness, and to hear the water crash in the absolute quiet of the last remnants of night, having only the morning star and a slight breeze with which to contend.

Experiences like these can happen anywhere. But they don't often happen with either the regularity or the strength that they did on the pilgrimage, where every day is an adventure, potentially surreal, and where feelings so unconnected with modern existence become a part of everyday life. For example, on any given day, you might get up early, before the sun, and have a quick breakfast of regional specialties bought the night before from the town's only baker, sitting outside the old pilgrimage monastery where you spent the night, eating as the sun comes up, staring like someone touched as the sunlight strikes beautifully on the place, casting it in a completely different light than the one you saw the day before, when you hiked in during the heat of the day. You might pick up an old Roman road a short way out of town, following the original pavement for miles, until it leads you to a small, ancient town where you can get a good cup of *café con leche* with the local farmers, who, almost consistently, are as interested in what you're doing as you are yourself.

Leaving the crumbling town, you might pass the ruins of a fourteenth-century castle, situated on a plain where Charlemagne was said to have defeated the Moors, whose castle this had been in one of its many previous lives. As you climb the ridge that has been looming in the distance all morning, you might pass a spring that appeared miraculously in the Middle

Ages at the command of the Virgin, after a certain thirsty pilgrim—who had foolishly said out loud that he'd do anything for a drink of cool water—successfully withstood the devil's offer of just that if only the man would turn back from his journey to Santiago. At the top, seeking shelter on the leeward side, you might have lunch in a twelfth-century pilgrim's hostel, looking down on the plains below as so many thousands of pilgrims have done before you, before the building fell into the ruin that it now is.

After lunch, the old Roman road—now paved over, now not—might take you right through the spectral remains of a medieval village founded in pre-Roman times but abandoned during the Black Plague of the fourteenth century, with walls and doorways right up on the edge of the road, the walls down now, but with bushes growing where they once stood and grass growing everywhere else, leaving an eerily precise plan of this ghostly town. As you approach your final destination in the steadily overpowering heat of the afternoon, you might first see the church tower of the place rise up suddenly over the horizon like a mirage in the heat waves, gradually growing taller, and then the entire town appears at once at your feet as you come to the ridge of the higher plains on the approach. After leaving your pack at the sixteenth-century *refugio* attached to the town's eleventh-century monastery—whose church was built up against the hillside in order to incorporate into its apse a cave that had been a pre-Christian holy place and in which an image of the Virgin had miraculously appeared in the Middle Ages—you might have a beer in the town square, listening to the death knell of the funeral being held at the parish church that faces the square sound out as it has for fifteen hundred years, watching the different reactions of the locals as they instinctively look up to see who has died and who is at the funeral. After seeing the sunset from the castle on the hill above

the town, you might have dinner at a small place, where the family that owns it has made almost everything themselves—including the wine made from grapes they have crushed with their own feet—rushing back to the monastery before the huge wooden doors are bolted shut at curfew.

Hardly life-changing in themselves, the vast number of these little experiences added up, creating a feeling that wasn't easy to describe to my friends after I returned: that the unique conveyed exactly the same impression as the everyday. In fact, I remember thinking of certain days as completely uneventful on which three or even four experiences took place that I'll remember my whole life. But if the unique had become the everyday, the everyday could take on the sensation of being unique—a feeling probably brought on by the regularity of these experiences combined with the at times extreme rigors of the road, the physical deprivation, the hunger, and the thirst, something that gave these experiences a feeling way out of proportion to what we today call reality and that the pilgrims of the Middle Ages would have seen as very special indeed.

To take a small example: one day, in the early morning fog, I stopped to watch an old man cutting the tall grass with an ancient two-handed scythe. Lothar, who had our map, got far ahead, swallowed up in the fog. There was a very odd atmosphere to the place, one that had been building and building as the fog got thicker and thicker, an atmosphere brought about by the fog's complete muffling of all background sounds and limiting of vision, but which feeling—as opposed to reason—interpreted as my being somewhere strange, somewhere not normal, even though I fully knew this was nonsense. As I wound my way through the *corredoiras* (footpaths lined with high stone walls that go back to pre-Roman times), a particular type of stone Galician corncrib—small, rectangular, raised high off the ground, and often crowned with pediments with

small crosses on top—kept materializing out of the fog here and there, looking like some spooky kind of mausoleum. The walls of the *corredoiras* were so high, and the fog so dense, that almost all I could see were these sepulchral visions, high, and against a totally blank background of gray fog—not used anymore, not serving any purpose, but to wait and watch for strangers passing through. I turned left, right, right, left, in this maze—unable to see where I was going in the high *corredoiras* that were dripping from the increasingly heavy fog, covered with the patina of centuries. Moving uncertainly down the trail, I came to a fork in the road that wasn't marked. As I stood there, wondering which way to go, knowing that the wrong choice would result in my losing my way, I was very aware that the effect of wandering through these labyrinthine passageways shrouded in fog was disorienting, almost mystical, almost a metaphor of the entire pilgrimage: this questionable undertaking of uncertain purpose.

Suddenly, I looked down at the muddy ground and there, right at my feet, was an arrow pointing the way—why hadn't I seen it before?—an arrow identical in shape and color to the painted ones used as way markers on the pilgrimage road, but painstakingly made from scores of small flowers, each glowing pure and clean in the mud. It struck me immediately as something special, a "fortuitous event" as is sometimes said in medieval miracle stories. Someone had made it early that morning or late the night before, I knew, but I also knew that, in the Middle Ages, such a small event could be seen as a miracle—a "merry miracle" as described in one account—from everyday life. Though I am no believer in miracles or the otherworldly, the feeling was not ordinary, all the more so because I'm a very rational and pragmatic person. There is a feeling in the pilgrimage for those who are long on the trail, and it has nothing to do with New Age or necessarily religious sensibilities. You

might not believe it, like myself, you might not understand it, but the feeling is there, no matter what you think. The pilgrimage is, above all, an experience, and must be experienced to be understood. The Greeks, famous for their rationality, knew this feeling: "These things are mysteries, not to be explained. But you will understand when you come," Sophocles wrote about an earlier pilgrim in an earlier age.

But it was the people that made the journey.

With his face eight inches from mine, and breathing last night's garlic in *my* face, the beggar gave me his opinion on the meaning of the whole of the sculpted portal, the Puerta de las Platerías, in which the half-naked woman holding the skull appeared. To me, this was what the pilgrimage was all about. It was a special moment—despite the garlic—but, even so, only one of many. It meant nothing at all to him that I didn't speak more than a few words of Spanish. He knew this. The odd thing was, it meant nothing to me, either. As a matter of fact, the whole thing seemed so completely normal after my two and a half months on the road. For many, there's a great camaraderie on the road that creates a special feeling among pilgrims, a feeling that often extends to those who come into regular contact with pilgrims and that, to a large extent, comes about from the closeness of the pilgrims' way of life. Serious pilgrims stay in hotels only by absolute necessity. Otherwise, they stay in *gîtes* (in France) and *refugios* (in Spain), very inexpensive hostels where the pilgrims sleep in bunks, normally in one large room, men and women together. Along the road, they meet and then part, sometimes to meet up again, sometimes not, like raindrops slowly running down a windowpane, now joining, now parting, now just missing each other, now going their own way, to paraphrase a Danish pilgrim I met along the road.

Sometimes the experiences shared by pilgrims seemed to be mundane at first glance but, in their lasting impression, were just the opposite: such as the four retired German army officers who had taken an American kid who was traveling alone under their communal and efficient wing, working on the sores on his feet with all the care and concentration of a team of surgeons. Sometimes they were a bit more sensational, like the group dinner—taken over by Paco, thereafter referred to only with the honorific as Don Paco—all of the pilgrims of our *refugio* had in one forlorn town: a feast cooked by him in the middle of the street and one I don't think will ever be surpassed in my experience, accompanied by way too much wine and a local flaming drink, *queimada,* complete with pagan chant and rounds of singing; a feast that culminated in a near-riot when Spanish Civil War songs began to be sung and that was stopped only by the quick thinking of the volunteer who ran the *refugio,* who literally jumped up on her chair to shout the belligerents down; and that was followed by after-hour revels of heroic proportions. And there was the less sensational but equally distinctive: the White Rabbit, so called because he was *running* the thousand miles to Santiago and couldn't stop to talk (he was late, he was late); or the Dutch pilgrim who, like Salvatore in Umberto Eco's novel *The Name of the Rose,* spoke in fragments of Dutch, German, English, French, Italian, and Spanish, and sometimes, it seemed, in tongues.

But, for me, it was less the pilgrims than the people who lived along the road that made the pilgrimage such a special thing. A couple of places had local eccentrics who have devoted their lives to the pilgrimage. Just outside of Rabanal, in a spur of the Cantabrian Mountains, was one: Tomás, an enthusiastic crazy (how many saints in the Middle Ages must have been just the same!) who had a falling-down shack festooned with banners and painted slogans, and who greeted all pilgrims as

they passed by and had them come in for water and a rest—and, I think, to get something for himself to eat. Running around in flowing robes, he claimed to be a latter-day heir of the Knights Templar—the medieval religious order of knights popularly believed to be guardians of the Holy Grail—and to possess their mystical knowledge.

Deeper into the hills, we were stopped in what amounted to a narrow defile on our way into Molinaseca by a man—only slightly crazy—standing above, on the top of the defile, who demanded to know where we came from and where we were going, medieval-story style, like a knight challenging all comers. He then questioned us about what nationality we were and how we liked this part of Spain, which was famous for its cherries. After answering most of these questions for us, he told us that pilgrims needed to eat a lot, and gave us handfuls of beautiful, perfectly ripe cherries, warm from the sun—the best cherries I've ever eaten. Overcome with emotion, he then passionately shook our hands, asked us to pray for him in Santiago, and kissed each one of us on the cheek with great exuberance—garlic again—climbing back up to his lofty and lonely post to await the next unsuspecting travelers.

One of my favorites, though, was someone we ran into at Barbadelo, a few days off from Santiago. There was an old pilgrimage road church there of local importance that we wanted to see, but the doors were locked, as is so often the case in rural Spain. Following the usual practice, we asked the farmer next door, the only person around, if he had the key. As it happened, he did; but the local priest, who lived in another town miles away, had ordered him to let no one in. Just then four Spanish girls came by, pilgrims, looking for water, and said that they wanted to see the church, too. The girls were pretty, and he decided that, well, maybe he'd let us in after all. The only problem was, he was too drunk, at eleven in the morning, to fit the

key into the hole. He managed, eventually, looking pretty sheep-ish—which was the only thing that had surprised me so far—and we were treated to a very unusual interior tower arrangement and an ancient baptismal font, all in extremely good condition. After a few minutes, he hurried us out, saying that the priest sometimes made unannounced visits!!! As he stumbled back to his house, which was the former pilgrims' hostel and hundreds of years old, he stopped, turned around, thought for a moment, and said, clearly by way of explanation, that he had "only himself and his animals," and then disappeared into the slowly crumbling ruin he lived in—leaving us to wonder whether he meant to explain that this was why he was drunk at that hour, or that, since he made a habit of being drunk so early, everyone but his animals had left him.

⌁

And there was, of course, the fingerless beggar. This was July 25, the feast day of Saint James, certainly the most profitable day of the year for this poor, literally threadbare man of around fifty-five. Yet it meant nothing to him that while he lectured me whole busloads of tourists were streaming in and out of the cathedral—lucrative earnings to be made—people who usually came into the cathedral talking to each other. A few might look around, one or two might even glance at the portal for a few seconds, at the most a minute. When I had first walked up to the portal to study it, the beggar hadn't paid any attention. But after fifteen minutes or so he began to take notice, glancing at me out of the corner of his eye again and again. After around half an hour, it was as if he couldn't contain himself any longer and, turning his back on this walking income, came right up and, without a word of introduction, began his lecture.

Certainly, he didn't treat all pilgrims the way he treated me.

Toward the end of the pilgrimage, 95 percent or more of the pilgrims are Spanish high school and college kids who hike little more than the bare minimum necessary to receive the Compostela, often beginning from nearby Ponferrada, the site of the Knights Templar castle that's said to be the hiding place of the Holy Grail, as if they were on a week-end camping trip with the scouts. And it wasn't simply because I had been at the portal for so long that the beggar came up. In vastly different ways, I had encountered this same reaction all along the pilgrimage. Without any self-consciousness or vanity, I'd come not so much to expect this behavior as simply to find it to be a part of the way of life that this two and a half month journey had become. Generally, this was because I, like the other long-term pilgrims, had gradually come to have a certain look, a look brought about by the hundreds upon hundreds of grueling miles walked in at times impossible circumstances toward this very nebulous end. I had this look and the beggar knew it. The Spanish kids who were week-end pilgrims knew it and stepped aside, as they say in tales of the Old West. And others knew it.

For example, in a market in Ponferrada, where so many hundreds of new pilgrims gather to begin their short trip to Santiago, I went to buy an apple. The young woman in the fruit section weighed it, put the price on the bag, and then, with a conspiratorial look, slipped another apple into the bag, gave me a wink and a very big smile, and said, "Don't tell anyone"—a small gesture, perhaps, but has it ever happened to you, at your supermarket at home? Even though I had just showered and put on a clean change of clothes and wasn't wearing my pilgrim's shell—a scallop shell hung round the neck, the badge that since medieval times has identified a pilgrim to Santiago—I was clearly in a special group: the long-term pilgrim, worthy of immediate public informality, warmth, and help, no questions asked. People driving, former pilgrims, stopped their cars,

greeted me, offered words of encouragement, and wistfully went their way. People walking stopped me, some jokingly asked what great sin I had committed that forced me to undertake such a grueling penance. Others asked me to pray for them; one horribly desperate man clearly needing it, or something, very badly. And in one small mountain town in Spain where we had stopped to have lunch in the square, two very old ladies came out of their house to see who we were, and actually blessed us when we told them we were pilgrims. I've certainly never had anyone do that before who wasn't a priest. In another town, Melide, we were stopped as we walked down the main street, past a square, around eleven in the morning, by a priest who—with three older men, apparently old friends—grabbed me by the arm and pulled me into the group. He had clearly been having a morning tot or two with the boys, retirees all, and was feeling pretty good when he saw us: pilgrims, hard-core, long-term pilgrims. He asked us the usual questions, but with enormous enthusiasm. When he heard that I had been walking for over two months, he went into ecstasies, while one of the old boys—who were all in the highest of spirits and enjoying the entertainment to the hilt—solemnly commented that Saint James himself would see that I had walked so far when I arrived at the cathedral. They then shook our hands heartily and asked us to pray for them at Santiago.

The reactions of people along the route were as different as the people themselves. For example, at Lectoure, a beautiful town in Gascony, we were standing outside the best restaurant in town, looking at the menu posted there, reading it more like a newspaper than taking it seriously, and commenting how it was, sadly, beyond our modest means. Completely unknown to us, the chef and owner was standing right behind us, having a quick cigarette, in the charming but extremely narrow medieval street upon which the restaurant faced. When we

started to leave, he saw that I was wearing the pilgrim's shell, stopped us, and said he would fix us "a special dinner at two-thirds the price." The bargaining was fun, and the meal was magnificent. The chef himself served us at the table and took enormous pride in the fantastic dishes he set before us, always saying something like "What do you think of that?" as he placed one culinary masterpiece after another in front of us. Next to us, a table of Gascons laughed, joked, and talked with us throughout the dinner, alternating with the chef as well as his family, who all worked there and who all came out of the kitchen to talk with us while we ate. In an entirely different vein, at Puente-la-Reina, we went to see one of the old churches, which happened to be closing just then. When the priest who was locking up saw that we were pilgrims, he immediately forgot what he was doing and gave us a wonderfully extended tour, complete with his personal opinions on art-historical points and academic debates concerning the church, an ancient and venerable place he clearly thought of as his own. At another church, the priest, who was just getting into his car to leave, saw us, got out, took us into the closed sacristy to show us the church's ancient and cherished reliquary, opening it up for us to view the very relics themselves, something that rarely happens. At the famous monastery of Conques in the Massif Central, when a grouchy old monk who'd been scaring everyone in the excellent abbey bookstore learned that we were doing the pilgrimage to Santiago on foot, over two months away, his whole demeanor changed: he became warm and friendly, shook our hands, and showed real respect despite our relative youth.

Being a pilgrim, and especially wearing the pilgrim's shell at all times, is a different sort of experience. You are set apart in a way that's not possible in modern Western culture. For me, it was truly medieval in that being a pilgrim determined my relationship with others to a degree I would never before have

imagined possible. There is very little of the grotesque commercialism associated with the Santiago pilgrimage that is so readily found at such once-imposing pilgrimage sites as Rocamadour or Mont-Saint-Michel. You are, and eventually feel, very much apart from the rest of the world, a world with which you are familiar, but of which you are not at that moment an immediate part. The feeling is one of a certain distance over which you have very little control. You are a stranger in a strange land, a pilgrim, one who seemingly has little to do with the life of the places he or she passes through. And yet you have a purpose. A pilgrim is not a tourist. You have a deeper experience precisely because you are not an observer in the traditional sense of the word. Something changes. You are not exactly the same person you were before. The locals look to *you* as a special experience, as authentic. Despite the distance, you are a participator, an authenticator, even more than the locals themselves. You are part of the cultural landscape, part of the original reason for being and the history of many of the towns through which you pass. This *is* the pilgrimage route, and it is a deeply ingrained part of the identity of the towns and people along it. Yours is the experience of a fully reconciled alienation: the pilgrim at once the complete insider, the total outsider. This is why the pilgrimage is not a tour, not a vacation, not at all a trip from point A to point B, but a journey that is both an experience and a metaphor rather than an event. This is why the pilgrimage must be done on foot, never on bicycle; why you must stay in *refugios,* not in hotels; and why the journey should be long and hard. And this is why you then experience a place and culture in a way vastly different than as a traditional visitor or even as a local.

The physical context is an important part of the pilgrimage. Material expectations are minimal: food, water, a place to sleep. You're never really clean, your clothes are never really

clean, and you're rarely truly comfortable, especially when sleeping in the hot and cramped quarters of the *gîtes* and *refugios*. There is no cool water to drink, often little variety in most of the food, sometimes little or nothing to eat. There is no warmth when cold, no air-conditioning when hot, and usually nowhere to lie down when tired except in the dirt, rocks, and stubble of the fields.

What there is is enormous silence and solitude. And the result of all this—not just for me but for all the other long-term pilgrims I spoke with—was a sense of timelessness, or very slowly moving time; the sensation of a timelessness of progress, that time and distance, the seemingly basic components of all travel, no longer played a leading role in the journey. I completely lost sense of time and, to a certain extent, of space. I couldn't remember exactly where I had been the day before but, strangely, could remember every place equally well. Certainly, this had something to do with both the constant movement and its incredibly slow pace. Sometimes, I could see two or three days ahead and two or three days behind; not a normal experience for a modern American. Or I might come over a ridge and see a city that seemed to be right at my feet, only to find it still half a day off. Or a car might speed by me in the rain on one of the few highways I crossed, slapping me in the face with wind, dirty water, and exhaust, and I knew that where that car would be in one hour would take me five days of hard traveling to reach. One of the incredible things about the pilgrimage from Le Puy to Santiago is that, when I was still a whole month of rough trails away, I was excited about how close I was—and, when I was still two weeks away (with some of the hardest trail of the road still ahead), I became almost giddy with anticipation of my imminent arrival.

This feeling is not at all specific to me. Other pilgrims feel it. Those who sail across the Atlantic or Pacific may feel it, too,

though it's infinitely less pronounced than on the pilgrimage. For two and a half months, I never entered a car, taxi, bus, train, subway, or plane (not to mention never reading a book, paper, or magazine; listening to music or the news on radio; or watching television). After a life of seventy-five m.p.h. on the Santa Monica Freeway, it became a difficult thing to experience movement through space by means of humankind's oldest and slowest means of transportation, walking. It wasn't like driving through the country. It was more as if the landscape very slowly passed us by than we it. Sometimes, it seemed as if we became part of landscape, like the herds of auvergnat sheep— or a medieval peasant. In the course of this downshifting from modern to medieval speed, the pilgrimage acts like a mental sauna, sweating out the stress of daily life as you sit and watch the shadows of the clouds move slowly across the land, pass gradually over the hill, and silently cross over the stream, the cows, the low stone wall, and, finally, you. Your mind first stops listing the things you have to do next, then it quits going over what had been happening at work; soon you stop humming and whistling to yourself and, eventually, there's a certain "white noise" and you begin to notice everything: the course of the sun, the phase of the moon, which way the water flows, where the wind is from, how the clouds are forming, and how deep the Milky Way looks from the balcony of your fifteenth-century *refugio*.

To me, this is as close as the "curious" person can come to traveling "blind," the early medieval practice of "wandering for God"—the sense of wandering, lost at sea in the middle of an endless and ever-changing ocean of mountains, valleys, and plains, following seemingly directionless footpaths that often become little more than animal trails, experiencing places you would never experience in a lifetime of traditional travel. You wander. You are told the route, but it's all the same: it's all new,

it's all strange, it's all foreign, it's all a sea of strangeness and foreignness. The pilgrimage was, in some ways, the medieval layperson's equivalent of the monastic life. The medieval monk or nun led an internal life or "discipline" whose goal was to attain a particular spiritual place in a spiritual quest through the "abandonment" of the physical world. The medieval lay pilgrim did the same, but, by definition carnal as opposed to spiritual, he or she traveled through the material world rather than "abandon" it, following an external "way" whose goal was to spiritually attain a particular *physical* place in a spiritual quest, denying implicitly, though not explicitly, that the holy cannot be localized, its claimed localization being the whole point of the grueling quest.

As the beggar led me back to his door—for it *was* his door by some vestigial medieval right, the other beggars keeping strictly to theirs, as if according to guild rules—he asked me, formulaically, to pray for him. But then, suddenly, he became deeply enthralled with some new aspect of the cathedral, words rolling off his tongue with an enthusiasm that already long ago had raised this man in my opinion from a parasitic bum to someone who, whatever his condition in life, commanded real respect. This was not because he was a human being, as is so often and so insipidly said, like the other six billion of us, but because regardless of his personal state he had not so much risen above it as he had ignored it, refusing to recognize what was not necessary to recognize, seizing upon what his natural abilities and instincts had led him to—something he might never have had the luxury of realizing if other paths had not been barred, an attitude, in fact, that was rather common among the volunteers who worked in the *refugios* along the pilgrimage route. In this process of personal transformation, he became as much a part

of the history that surrounded him as were the uncomfortable looking priests who avoided eye contact with the hordes of tourists, the archbishop with his expression of deep, deep worry, the half-naked woman with her skull, and even the cathedral itself.

This is what the pilgrimage does, or can do. It forces the susceptible person to enter into one of the most fundamental elements of human existence, one that's almost systematically ignored in modern life, although it wasn't in earlier, less detached times: the simple recognition that history is part of existence, whether cultural or individual, that there is a past as well as a present, that the past has very much to do with the present, and that the past belongs to those who belong to the present. It is the deep and sustained integration of this dynamic of past and present along the pilgrimage routes that accounts for why the pilgrimage is not a vacation or tour but a journey, not a succession of postcard-worthy sites but a progression of time and space in which both the implicit denial and the embracing of time and space inherent in the acceptance of history operate. These sites, including Santiago, are not the goal. From the medieval point of view, the pilgrimage was not just the physical arrival at a holy place but the experience of progressing toward that destination, an experience that was as much a part of the phenomenon as was the holy place itself. From the modern point of view of the "curious" pilgrim, the pilgrimage is an intensely internal experience in an intensely physical context in which the journey, more than the destination, is the goal.

But it's also something more than that. People instinctively want something to believe in, whether they believe in anything much or not. From the medieval perspective, the pilgrimage was undertaken for the very specific reason that the great physical hardships of pain, hunger, thirst, exposure to the elements, and general loss of comfort and of all that's familiar are con-

ducive to inducing a mental state eminently suited for the spiritual exercise that the pilgrimage fundamentally was and can still be—to a certain extent, the adoption of monastic spiritual practices in the non-monastic medium of the visitation of a holy site: this was the purpose of such a long and grueling journey. For the modern pilgrim, the "curious" pilgrim, the vast epic quality of the pilgrimage still instills at the very least much of the sensation of a journey with a deeper purpose, but with this difference: that the undertaking is spiritual not in the sense of being religious but in the sense of having to do with the spirit. In the same way that a nonreligious person can listen with sensitivity to a Gregorian chant or read an unusually evocative passage of medieval religious prose or verse, he or she can, to a degree, still experience the pilgrimage.

But there still has to be a culmination to such an experience. And to me, that culmination was not Santiago itself. This was despite the Compostela and the stunning Pilgrims' Mass, which took place in the cathedral in a setting of sensory saturation so great that the eye hardly knew which way to look first—unless it was at the near-pagan spectacle of the *botafumeiro,* a giant, solid silver censer weighing 120 pounds that's swung from the ceiling in front of the high altar and that takes eight men to set into motion in its 180-foot arc through the transepts, a spectacle that causes the crowd to break into spontaneous oohs, ahhs, cheers, and wild applause, even though they are warned by the priests ahead of time to control themselves. This is something that has gone on for hundreds of years, as has the ritual at the main portal of the cathedral, the Portal of Glory, of putting your fingers into a set of holes worn deep by almost nine centuries of pilgrims, and of knocking your head against the head of one of the sculptures there—a ritual that sometimes creates a mob scene, with the older Spanish women clearly enjoying the chaos, pushing their way through the mass of people

waiting in the long, deep line, laughing with all their might, while the northern Europeans stand there horrified and at a loss as to what to do. Some people make up their own rituals and—since most people don't know the proper one and simply copy the person in front of them, assuming that this person knows what he's doing even if they don't—you might see any number of crazy rituals being performed throughout the day. No, for me, the culmination was the journey beyond Santiago, three days beyond, to Finisterre, *Finis Terrae* in Latin, the End of the World, that place where, in ancient times, the world reached its westernmost extent—ended—for the civilized peoples of the Roman Empire who made pilgrimages there.

The pilgrimage can be a complex thing. It's not at all necessarily straightforward. For most, the goal may be clear: Santiago, even for some of the very few who go on to Finisterre. But for me, as for so many medieval pilgrims, Santiago was inextricably bound up with Finisterre as part of the complex layering of history. Arriving at Santiago, I may have felt a certain sense of accomplishment, but not completion, in any way. The first sight of the cathedral at the *montjoie* (the hill from which the first view of a holy place is made; it traditionally marks the emotional high point of a pilgrimage) was fun but not emotional. The journey really *is* the goal, and the journey didn't end for me at Santiago, but at Finisterre. In pre-Christian times, it had been a cult center of Venus, one of whose attributes was the scallop shell, the same shell that became the symbol of the pilgrimage to Santiago. But in the Middle Ages, pilgrims considered it to be a part of the journey to Santiago. And so did I.

No one would come with me. Everyone was worn out, wrecked, on the verge of physical meltdown. Because this is such an untraveled region, there are no *refugios,* and hotels of any kind are rare. In order to have a place to stay—it's far too wet in this part of Spain to sleep out of doors without more

equipment than a pilgrim can carry—the second day had to be around twice what's normally walked, around thirty-four miles (fifty-five kilometers) instead of the customary fifteen (twenty-five kilometers) for long-term travel with a pack. For only the second time in the entire journey did I feel like a sacrificial lamb being led to slaughter—the first being the day before I left Los Angeles for France, after both my knees had gone out that very week during full-scale training.

The first day was a normal stage and went perfectly well.

The second day I had to travel hard and fast, harder and faster than I had ever traveled before so that I wouldn't get lost in the half-deserted farmland with its maze of poorly marked trails when the sun went down. It was ironic that such an impossible day would have come at the very end, when I was physically strained to the utmost with ruined feet, with knees that had become a parody of the real thing (working only with neoprene braces), and generally emaciated.

I got up way too early, the fog and the deep woods giving the savage barking of the farm dogs—canine shrieking, really, insane with pathological delight at the unexpected good fortune of having a stranger wander by alone in the early morning darkness—a completely surreal quality.

This isn't the place to describe what happened next. Let me just say that after I was attacked by four certifiably homicidal German shepherds at once—two in front and two behind, crazy with bloodlust, both blocking the road in the direction I absolutely had to go and keeping me from turning around and trying to find another, less lethal route—everything changed and I found myself in a countryside so beautiful that there was a palpable sense of enchantment, a place far from anywhere, a land that seemed to have been wholly untouched by time. With my earlier, almost mythological trial forgotten, I walked down endless miles of dirt track, now open, now bordered with

trees, now lined with centuries-old walls of stone, eventually coming to a crossroads at which there was one field that was different from the rest: a walled field with a large arched gateway, such as I had never seen before, as if the remnant of some now-vanished golden age of prosperity. An old woman was working in the field, all alone, no village or house in sight, wearing the traditional black of a widow and struggling with an old, heavy hoe, probably hand forged, the likes of which certainly couldn't be bought today. She was moving very slowly, as if she were afraid she might fall over—who could ever help her way out here? As I walked by, she was slowly leaving the field and I said hello. She looked up at me, a bit in surprise; there couldn't often be anyone way out here but one or two of her neighbors. Her face was aged, even ancient, with watery blue eyes appearing as strikingly displaced islands in a cross-blown sea of deeply sunned, weathered skin that only a very long life of hard work and exposure to the elements can create. I had expected a mumbled response, perhaps even to be ignored—pilgrims were rare out here. But when she saw the pilgrim's shell I wore, she flashed me a brilliant smile and waved her hand as high and vigorously as a high school cheerleader. But this was not the wave a Tennessee countrywoman would have given to a backpacker doing the Appalachian Trail, or a Cumberland farmer to a Lake District day trekker from London. Rather, it was specific to the pilgrimage, and this is part of the reason the pilgrimage is a potentially unique experience, whether a person is religious or not. Infinitely rich layers of history bind the pilgrim and the people who live along the pilgrimage routes together in a relationship that asks for no formal logic.

After a while in which no time seemed to pass, I approached the top of the hills that overlook the sea and lead down to it. If my first glimpse of the cathedral of Santiago had been unemotional, that was not the case when I passed over the ridge

and first caught sight of the Atlantic Ocean after two and a half months and a thousand miles of punishing trails. I stopped and stared and knew that my journey was not yet over, but that the end was in sight, something that didn't seem to be the case even as recently as that very morning because of the incredibly monumental demands of this second-to-the-last day.

After spending the night in a seaport at the base of the Finisterre peninsula, I could barely walk for most of the last stage because of the almost impossible wear on my knees. All but crippled, I hobbled horribly until sometime after noon, by which time I was approaching Cape Finisterre itself.

The weather was stunning. The sky was brilliant, clear, with only a few clouds, just enough for effect. It was just barely warm enough, and there was just enough breeze to let you know it was a gift. The sea was astonishing. The water was a beautiful jade in the shallows and a dark, rich blue in the deeper water. There were occasional oceangoing freighters, a scattering of fishing boats taking their time, and one or two sailboats—no more. The coast was ragged and rocky, with small sandy coves alternating with long stretches of white sand beaches. The air was perfumed with the scent of the pine, cypress, and eucalyptus that cover the rough hills and that grow down to the cliffs and shore. Jagged granite speckled with lichen littered the landscape, and there were occasional plush growths of fern.

As I wandered the last fifteen or so miles along the coast of this forgotten paradise—lost, almost, as in a dream—it became clear to me why medieval pilgrims on this already impossibly long journey to Santiago saw Finisterre as part of their goal. It was because the pilgrimage is historically layered, in this case with the pre-Christian element that was so strong in the popular culture of the Middle Ages asserting itself in the Christian continuation of the originally pagan pilgrimage to this entirely

pagan site—one of the places from which the scallop shells, the sign of the pilgrimage to Santiago, three days off, come. When I later mentioned to a Spanish pilgrim back in Santiago that I had continued on to Finisterre, the first thing she asked was if I had burned something there—part of an old pagan practice that continues with enthusiasm today.

At other places, it's different periods of culture that emerge most clearly from the blend of which they are all a part. If, at Finisterre, the historical emphasis of the pilgrimage is on the pagan Roman, at the pass at Monte Irago, in a spur of the Cantabrian Mountains, it's on the pagan pre-Roman, with its famous Cruz de Ferro, a huge heap of stones that travelers, including me, have continuously added to since before recorded time. At the seaport of Padrón, near Finisterre, it's an Early Christian layer, the pilgrimage there focusing on the miraculous arrival in that town of the body of Saint James after his death— the Roman milestone that marks the spot and that stands under the high altar of the church of Saint James there being the most amazing presentation of a historical remain or relic that I've ever seen. In the Pass of Roncesvalles, it's Carolingian, with the historical element making the distant presence of Charlemagne ever-present—as it is in the countless medieval sculptures of Roland that line the route. Santiago itself exudes an air of the Reconquista, the great period of the pilgrimage. But these are all mixed, layered, interwoven, and would have been even more so in the Middle Ages with the epics of *The Song of Roland* and *The Poem of the Cid* being sung all along the route.

Everyone stared as I began to get near Finisterre. People driving by honked their horns and shouted. Others waved. When I reached the point of the cape, they stared as well, but only from a distance. They pulled off now, no one got too close, no one looked me in the eye for more than a split second: it was the end of the journey, the End of the World, something was

happening, everyone knew, but just what is better sensed than defined, as Sophocles knew.

The entire pilgrimage *is* something that is better sensed than defined. Even the memories are feelings more than stories in the traditional understanding of a travel tale told: the almost over-whelmingly timeless quality of eating cherries and grains of ripened wheat picked from the fields as we walked along a lost valley in the mild heat of a Spanish afternoon; the strange sen-sation, both spooky and fun, of sleeping in the old monks' cemetery of the forebodingly remote Sauvelade in France, un-able to find any level ground because of the centuries' worth of depressions left by the rotting bodies underneath, complete with low-flying bats and inexplicable rustlings from an old heap of gravestones nearby; the oddly displaced sense of living a piece of nineteenth-century travel literature when, talking to my wife and daughter at their leisurely Sunday morning break-fast in southern California by phone from outside an old tav-ern in Ostabat, in the Pyrenees, after an unusually grueling day, I held the phone outside the booth for them to hear the bois-terous, drunken singing of a Basque wedding party that had taken over the place; the riveting, gothic-novel feeling from sit-ting in the dark among the tombs of the former chapter house of the once-powerful abbey of Roncesvalles during a thunder-storm shortly after the sun had gone down, watching the stained glass windows of the saints and founders come mo-mentarily and fiercely alive during the lightning flashes directly behind them—almost as if they were denying, so futilely, that they had fallen from power; and so many others.

And there were also the funny little habits of the afterlife of the pilgrimage, feelings more than acts, that immediately conjured up on-the-road sensations: little things like absent-mindedly checking my shoes for small stones when I put them on in the morning at home; unthinkingly making sure I knew

where my next water source would be when I left my house to go to work; or—as happened when I got off the night train from Santiago to Paris and was walking to my hotel in full regalia soon after the sun had come up—instinctively and instantaneously going into defensive position with my staff at a threatening angle, like a soldier holding his bayoneted rifle at the ready, when the stunned dog of some urbane Parisian suddenly emerged barking from its tastefully decorated apartment with its equally stunned master and decided it didn't want to go outside for a walk after all.

The pilgrimage—a tale of storm, rain, heat, cold, sunburn, windburn, hunger, thirst, snakes, rabid dogs, blisters on top of blisters, winds that can stop you dead in your tracks, and knee-grinding and ankle-breaking trails—creates in many an instant nostalgia. Taking the express train out of Santiago with a handful of other pilgrims, all instinctively huddled together in the same compartment, it was astonishing to see how excited they became when we went by a clearly marked section of the pilgrimage trail near León—and then to notice the sudden silence when a lone pilgrim, slowly walking the trail, came into sight in the distance. On foot, the view was up close and personal. But on the train back, it was striking how distant it had suddenly all become: there was a much broader view now, but one that was totally removed, sheltered, air conditioned. There was no wind, no heat, no bugs, none of the tons of cow droppings, sheep droppings, and goat droppings that the pilgrim daily forges his or her way through. In a car, you're closer, but it might as well be television, you go by at such a great speed and in such a hermetic, self-contained world. There's something about the experience on foot that seems to sharpen or even change the perception, something that's undoubtedly induced in part by its great length and difficulty. I've seen many beautiful sunrises, but none like those I experienced along the trails

in Spain in the early morning, with the rising sun right behind me and my long shadow pointing straight, exactly straight, ahead, like some mystical sign indicating the way, directly west, to the End of the World. I've seen many beautiful sunsets, but never one like that at O Cebreiro—having just had one of the cheeriest meals of the entire pilgrimage in a centuries-old pilgrim hostel—high on the ridge of the last big mountain range that we had to cross, with the wind hitting us from both sides, from where we'd just been and from where we were about to go. But it's not just the physical aspect that induces these feelings. There's also the awareness that you are doing what so many before you have done, and what so many others will only dream about: the Great Journey. And it's not just the pilgrim who feels this. When I was a kid and used to spend my summers riding the freights along the Pacific Coast and we'd slow down to pass through the small, hot California towns, a particular type of person would often look at me as I lay on top of the boxcar—not at me as an individual, but as someone who embodied something they wanted at that specific moment of their lives. Sitting there in their cars at the railroad crossings, it was always men with young children who would stare—and then wave, wave spontaneously, with a certain look on their face. I got that look many times on the pilgrimage, sometimes from men, but now mainly from women around forty to fifty-five years of age. This was not the look given to vacationing tourists.

I purposely hadn't given alms to the fingerless beggar because it was too fine a moment, the layering of history was too rich: it had probably been one of his very predecessors at this very portal who first told that tale about the half-naked woman with the skull, almost nine hundred years earlier, to the author of

The Pilgrim's Guide. Though I always thought that it had originally been done with a mercenary bent, I felt this wasn't the case with the fingerless beggar, but wanted to see for myself, to be sure. I let him talk on and on, repeating much of what he said twice in case I'd missed it the first time, acting it out whenever possible. Finally, he finished. I thanked him twice, formally, drawing it out, looking him right in the eye. There was none of the usual shifting of feet and restless movement of hands that typically take place when someone expects a tip for unsolicited services. If anything, there was a mild reluctance on his part to go back to work, for work it was. He would rather stay and talk with me about the cathedral and the pilgrimage, but it had already been twenty minutes, with little more than "Sí, sí" from me—saying yes to everything he said, whether I knew what he was saying or not, since he kept looking for understanding on my part. So I thanked him again and let him walk back to his post, back to his begging for alms on this important day, and I went back to my work, looking at the portal. Later, when I was done for the day, I walked over to him and gave him a good alms, which was returned with a look that made it plain that he expected no gift for the lecture but was willing to accept something as his right as a poor man, the beggar of this door, the beggar of the Puerta de las Platerías.

Leaving the beggar, I went into the cathedral again and no, I didn't pray for the beggar, or for the desperate man, or the drunken priest and his friends, or for any of the others who had asked me along the way to pray for them. But I thought about them as I stood in the transept during one of the many masses that were celebrated there that day, possibly the only stationary figure in the entire church aside from the sculptures, amid bellowing clouds of incense, as the wall-to-wall crowd went wild with the illusion that the *botafumeiro* would alternately smash through them on its outward swing or come crashing

48

down on their heads on its return. And it wasn't with any cynicism that I did this. For, despite my shadowy status as one of the "curious," I was as much a part of the pilgrimage as them, as much a part of it as the fingerless beggar of the Puerta de las Platerías.

VIEWS OF THE
JOURNEY

► The chapel of Saint-Michel d'Aiguilhe, standing on the outskirts of Le Puy, the starting point of the pilgrimage route that runs from Le Puy to Santiago, still evokes the medieval pilgrimage despite its scoured walls and almost completely gutted interior. One of the great remnants of an age in which it was passionately believed that the holy could be localized, it was consecrated to Michael the Archangel, having been built on the site of an ancient Roman temple probably dedicated to the god Mercury, which itself seems to have been constructed on an earlier pagan religious site since a prehistoric menhir (a monolith, originally standing) has been incorporated into the chapel's foundation. Saint-Michel was begun in 962 and progressively added to throughout the eleventh and twelfth centuries. The original tower was destroyed by lightning not long after it was built.

PHOTO: OFFICE DE TOURISME, LE PUY EN VELAY

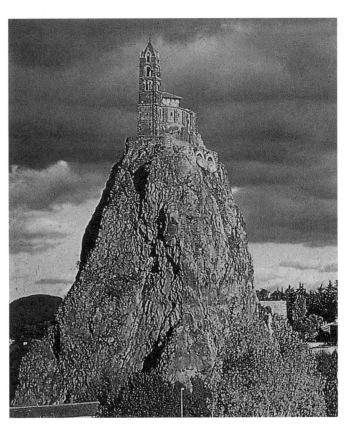

► A limping and decimated procession of ancient stone crosses greets the weary pilgrim all along the pilgrimage route like ghosts from the past, a few still ensconced in the heart of some snug French or Spanish town, a source of pride and identification to the people who live there, others lost out in the wilderness, broken and alone. At times, stone crosses like this were set up as manifestations of secular and ecclesiastical authority, an authority that is still remembered by the local people in a number of places. The Croix de Jalasset, seen here, was erected in 1621. The cross that had once stood so proudly at its top fell in some earlier time, perhaps during one of the storms of religious violence that troubled France for so many years. PHOTO: ERIC DOUD

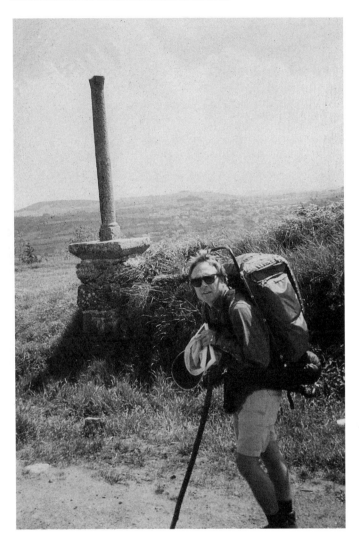

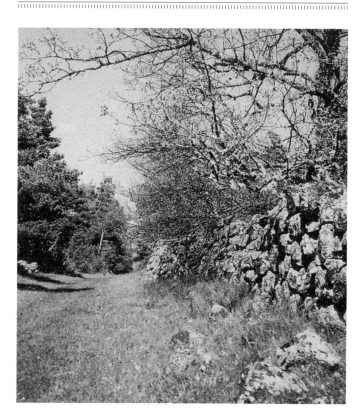

▲ The journey through the Auvergne and the Lozère in May, the traditional time to begin the pilgrimage, can be one of numbing cold, stultifying heat and humidity, violent winds and pounding rain, impassable pools of mud, ankle-breaking and rock-strewn trails that turn into actual streams when it rains—and countryside as overpoweringly beautiful as it is devoid of human activity. PHOTO: ERIC DOUD

▼ Though the countryside generally becomes more populated once the trail begins to leave the High Auvergne, the pilgrimage route doesn't follow the traditional highways here—which run along the river valleys with their beautiful walled towns—but crosses over from valley to valley, and can be very rough traveling. The upland areas between these river valleys are often very wild, something that—when the trail drops down, after days of slow and knee-grinding progress—can cause the small but prosperous towns like Espalion, seeming to materialize from nowhere, to come as a bit of shock to the increasingly worn and tried pilgrim. PHOTO: ERIC DOUD

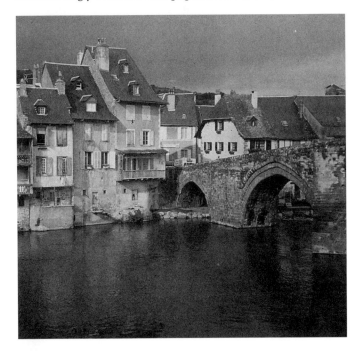

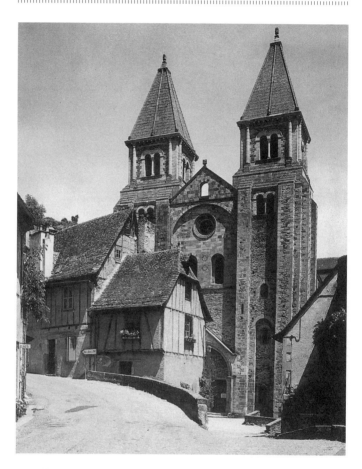

▲ In the blink of an eye, I saw something in the sculptures of the great portal of the pilgrimage monastery of Sainte-Foi at Conques—carved in the early twelfth century, at the high point of the medieval pilgrimage—I had never seen before, despite looking at photographs ▶

of them for years. With staffs in hand as I and my little band rounded the corner of the square in front of the ancient church and drew closer, it struck me immediately and instinctively, as a pilgrim, that the tight band of the Saved in this Last Judgment scene—an unusual number of whom are holding staffs of some sort—were meant to be directly identified with in the Middle Ages by their original audience of pilgrims, virtually all of whom would have been carrying staffs as well. Some people then considered pilgrims to form an order of the Church (along with priests, monks, lay people, and virgins), and their staffs were such a characteristic part of their identity that these were actually blessed in a liturgical ceremony accorded to pilgrims upon their setting out. The ceremony was based on the one for knights departing on crusade, the pilgrim's staff being as much a symbol of his or her status as the sword was of the knight's. PHOTOS: JAMES AUSTIN (OPPOSITE); ALISON LANGMEAD (BELOW)

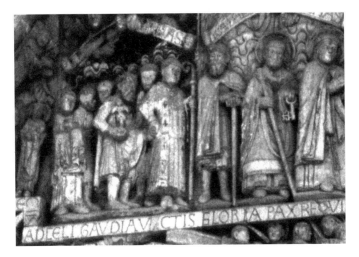

▶ The hilly expanses in between the stunning river valleys of the Lot region were used for grazing and orchards for centuries. But the changes that have taken place since at least the nineteenth century have left them all but deserted, with only silent vestiges of the idyllic life that once went on in them remaining, like the scores of increasingly overgrown shepherds' huts. While it is impossible to say how old these huts are—the tops of some show evidence of having been rebuilt many times—the lower parts are probably centuries old, and the building type itself goes back thousands of years to prehistory. PHOTO: ERIC DOUD

▶ The twelfth-century entrance to the church of the great pilgrimage monastery of Moissac, constructed at the height of the pilgrimage, is one of the great sculpted portals of the Middle Ages. The main sculpture over the doors depicts Christ in Majesty, while the sculptures of the side walls—at face level of the visiting pilgrim—chastised pilgrims for their greed and lust in the most graphic manner imaginable. The portal, clearly aimed at a pilgrim audience, does not lead directly into the church, but into a narthex or forehall of the church. Whatever the liturgical function of this narthex was in the Middle Ages, nothing could have been clearer to me when I reached Moissac on a hot June day—probably the same time of year that the crest of the annual pilgrimage wave would have passed through Moissac in the twelfth century—that its social function was one in which the medieval pilgrim came as close as he or she ever would to an air-conditioned room: cool, out of the sun and wind, off the trail and street, a place for pilgrims to rest while the church was closed to the public during most of the day for the regular monastic services from which they were usually excluded.

The monastery had had a decent pilgrimage, largely based on the miraculous font of Saint Julien, where pilgrims came to be cleansed of both sin and disease. Lepers in particular made the pilgrimage to Moissac to be cleansed at the font—until it became contaminated with leprosy, the disease spread to the monastery, the font had to be closed, and the monastery began looking for other sources of holiness with which to attract pilgrims. PHOTO: JAMES AUSTIN

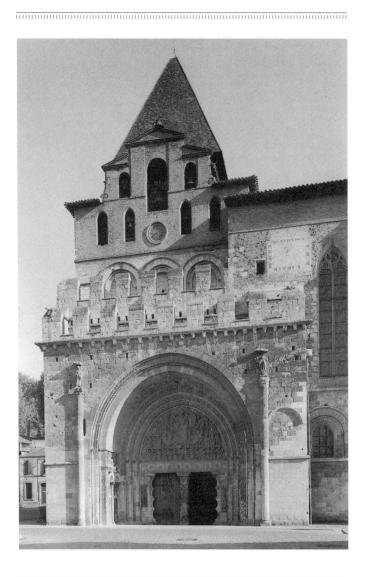

▲ In a place not much different from this, a young woman appeared to us almost as if in a vision. Halfway between Ostabat and Saint-Jean-Pied-de-Port, in the Pyrenees, at a place where the valley pass narrowed and the trail ran past a clear, cool stream, we walked around a bend to find a beautiful young woman sitting on a large rock projecting into the water who, at first glance, gave the impression of being a water nymph or naiad, given the absolute wilderness of the place. But, no, she was from a farm in the hills and was selling drinks chilled in the water in order to make a little extra money for school. We were her only customers all day, and her striking blend of delicacy and bare feet—a bit like a Basque version of how one imagines the "glimmering girl" in Yeats's "Song of Wandering Aengus"—made it seem as if she might vanish after we walked around the next bend in the trail. PHOTO: LOTHAR VON FALKENHAUSEN

▼ The pilgrimage routes were spaced all along the way with holy places ranging from strong regional cults to truly imposing international sites, holy places in which the pilgrim could experience the localization of the holy in the most intense way. But the spaces in between might be no less intense at times for the pilgrim with little or no familiarity with the world outside of his village or town. It was certainly no accident that in the sculpted portal of the famous pilgrimage church of Saint-Lazare in Autun, Burgundy, only one figure among all the Saved depicted in the Last Judgment scene is portrayed with vegetation at his feet: the pilgrim to Santiago. The twelfth-century *Pilgrim's Guide* offers a rare glimpse of a pilgrim's reaction to one of these spaces in between, the greatest work of nature on the route to Santiago: the Pyrenees. About reaching the summit of the Pyrenees, the author writes, "its height is so great that it seems to reach all the way to the heavens—to the person ascending it, it seems that he himself is able to touch the heavens with his own hand"—a reaction not so different from that of the modern, curious pilgrim. PHOTO: ERIC DOUD

► The abbey of Our Lady was established in the early twelfth century at Roncesvalles, situated in one of the passes through the Pyrenees most heavily used by pilgrims. It was founded at this site by the bishop of Pamplona and the king of Navarra to serve as a hospice because thousands of pilgrims had lost their lives in the snows of the pass, their bodies eaten by wolves. It soon became an institution of fabulous wealth, with holdings throughout western Europe, and one of the great pilgrim hospices of the Middle Ages. Shortly after its founding, the abbey of Roncesvalles became identified with the site of the ambush and defeat of the rear guard of Charlemagne's army in 778 under the command of Count Roland, as told in the famous epic *The Song of Roland,* although the actual location of the battle is unknown. The abbey soon developed this claim systematically, in the process merging the pilgrimage to Santiago with French political influence in northern Spain through the historical ideal of Charlemagne. Pilgrims were shown the tombs of Roland and the other Twelve Peers of France; the sword, ivory horn, and split rock that are such a dramatic part of the legend of Roland's death in the epic; and many other secular relics of Roland, Charlemagne, and the battle. By the twelfth century, close to a thousand crosses had been planted by pilgrims at one of the summits just above the abbey in emulation of the one that Charlemagne himself was said to have raised there upon entering Spain with his army in the late eighth century.

Eventually, the greatness of Roncesvalles was such that it became a burial place of the kings of Navarra—an astonishing thing given how remote the site is—and war relics from later, important battles were brought to the abbey in recognition of its standing. PHOTO: EDITORIAL EVEREST

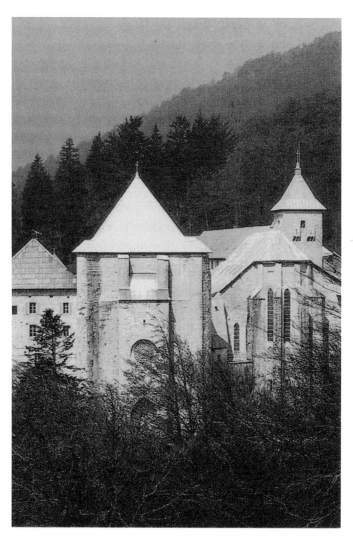

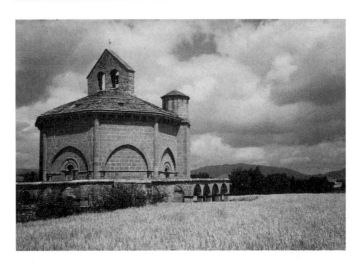

▲ While the specific intention behind the foundation of the church of Eunate, in Navarra, remains unknown, some scholars believe that it was founded to serve the pilgrimage because graves of several people wearing the scallop shell, the badge of a pilgrim to Santiago, have been found there. However, not only were many churches along the way both formally and informally bound to bury the pilgrim dead, regardless of the basic function of the church, but, as I saw only too often along the route, the graveyards of all of the old churches are so filled with ancient graves that each handful of earth turned up is absolutely littered with human bones. Whatever the original purpose of Eunate, every church along the road to Santiago must have its share of pilgrim burials, shell or no shell. The actual pilgrimage roads themselves must be lined with untold numbers of forgotten graves of pilgrims who died along the way, never having obtained the miraculous cure they wished for at the end of their journey. PHOTO: ERIC DOUD

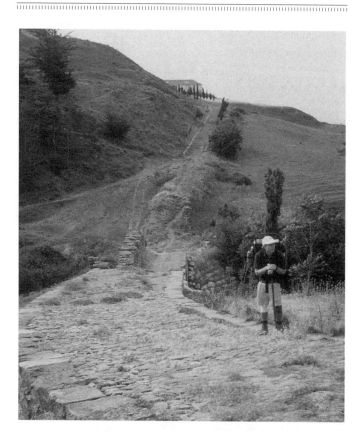

▲ For me, one of the great experiences of the pilgrimage was walk-
ing along great stretches of the original surface of the Roman Via Tra-
iana, which has been in continuous local use, in whatever state, since
the Empire. This particular expanse—several miles long and with an
only partially restored Roman bridge—is at Cirauqui, in Navarra,
on the route from Puenta-la-Reina to Estella, one of the most extraor-

dinary stages of the Spanish route. Elsewhere along this stage, the pilgrimage road passes through the remains of a pre-Roman town, two abandoned medieval villages, several medieval bridges, quite a few ruined medieval hermitages, the ruins of a pilgrim's hospital (a hostel and hospital run by the Knights Hospitaller, later known as the Knights of Malta, a medieval military order dedicated to the care and protection of pilgrims), any number of still-functioning medieval churches, and even a medieval palace. Estella itself is one of the most interesting towns of the Camino, though it has much competition.
PHOTO: ERIC DOUD

▶ Few sites evoke the day-to-day experience of the medieval pilgrimage with such immediacy as the medieval bridge at the Río Salado (Salt River) crossing. It was about this place that the author of the twelfth-century *Pilgrim's Guide* tells the story of how he and his traveling companions stopped to rest and water their horses. They asked two Navarrese, who were sitting on the riverbank sharpening their knives, if the water was good, and the two—no doubt staring at them like vultures—answered that it was. When the group watered their horses, two of the animals died immediately, and the Navarrese, with their freshly honed knives, proceeded to skin them on the spot. This was apparently how they made their living. The author of the guide, who was French, doesn't say a word about what happened next, leaving the reader to assume that his group went meekly on its way, these Navarrese being the same kind that he bitterly describes a page or two later (from firsthand experience, apparently) as willing to kill a Frenchman without thinking twice about it. PHOTO: ERIC DOUD

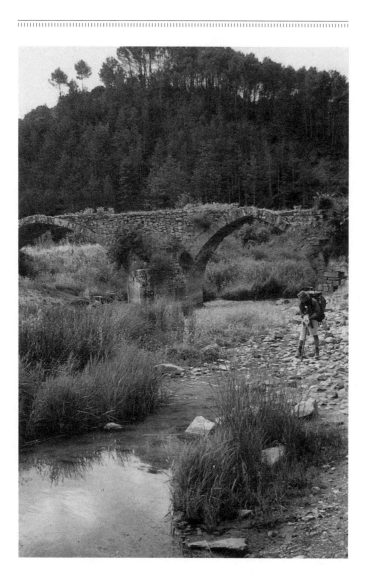

▶ The pilgrimage route has no shortage of local people who seem to be even more consumed by the pilgrimage than most pilgrims. We ran into one of these outside of Logroño: an old woman, almost completely blind, who lives in near-poverty on the edge of the pilgrimage road entering the town. Pilgrims carry cards that are stamped daily to prove that they have walked and not driven. The cards allow pilgrims to use the inexpensive *refugios* and act as documentation for the Compostela. Usually stamped at the *refugios* themselves, it's a mark of the esteem in which the pilgrimage is held that a friendly competition over stamping seems to have arisen among other places of pilgrim traffic, such as cafés and historic churches. It's not at all unusual for a barmaid at a café on the pilgrimage road or a priest at an ancient church to insist on stamping your card. This old woman of Logroño has a near-monopoly on her part of the road, spending the entire day, every day, stamping pilgrims' cards. With a stamp that gives her name, the name of the town, and a depiction of a few figs and a pitcher of water—along with the inscription, "Figs, Water, and Love"—she gives out figs from the tree that grows overhead, water from the tap in her yard, and an irrepressible cheerfulness to all pilgrims who come by. PHOTO: ERIC DOUD

▶ Only a few stragglers remain on the ancient street that passes through the heart of this town in northern Spain—bustling just a few minutes before—as it shuts down for the midday meal and accompanying siesta, during which the inhabitants close themselves off as best they can from the oppressive midsummer heat. The Spanish pilgrims, too, find somewhere to rest during the siesta. Once, when we were getting up to leave the coolness of the thick stone walls of the tavern where we had stopped to buy drinks shortly after noon, a group of Spanish pilgrims relaxing on the wooden benches there quickly looked at each other, smiling, and asked us why we were leaving. Were we really going to walk in the heat, they asked. They knew the answer before the question was asked, of course, the young women in particular clearly enjoying teasing us and having their preconceptions about "mad dogs and Englishmen" confirmed. PHOTO: DAVID HERWALDT

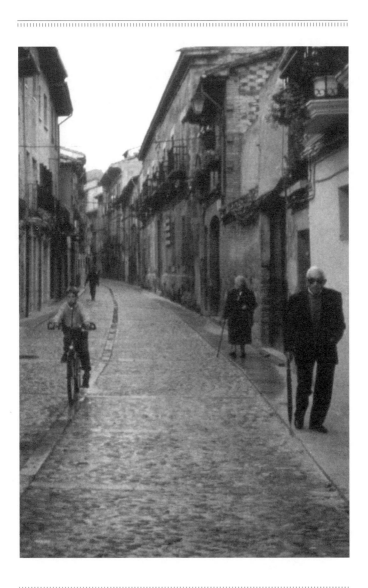

▶ The pilgrimage to Santiago has been a living institution for almost twelve hundred years. Throughout the course of time, some aspects of pilgrim culture wither away, others spring up new, and still others continue, century after century. One that has endured is the body of observances commemorating the medieval miracle of the chickens at Santo Domingo de la Calzada, in the province of La Rioja. The tale varied throughout the Middle Ages according to time and place. But as told at Santo Domingo, a father, mother, and son stopped at an inn in the town on their way to Santiago. The daughter of the innkeeper made certain advances toward the boy, who miraculously (although this is not what was meant by a miracle in the Middle Ages) resisted her charms. Hell hath no fury like a woman scorned and, scorned, she hid a golden cup in the boy's bag and accused him before the authorities, and he was hanged at once. Upon leaving town, however, the grief-stricken parents heard their son's voice speak to them, saying that he was not dead, that Santo Domingo was actually holding him up. Running back to the magistrate, they told him what they had heard. The magistrate, who was about to have a nice dinner of roast chicken, replied that the boy was no more alive than the chickens on his table—at which point the birds stood up on their platter, crowing and clucking, and the boy was returned to his parents unharmed. For at least six hundred years, a rooster and hen have been kept in the church in commemoration of the miracle. They quickly became fully integrated into the local pilgrimage culture, and their cackling at particular times has come to be seen as a sign of good luck to pilgrims, as is their eating bread offered to them on pilgrims' staffs. If anyone doubts the truth of the tale, the boy's tunic and chains still hang on the wall next to the cage as proof.
PHOTO: ERIC DOUD

▶ It's a peculiar feeling, at times, to travel slowly cross-country and see the many churches and monasteries that were once so costly, so socially integrated, such sources of pride, and such centers of power and conflict in the Middle Ages, now often so neglected. In Spain, some of these have been converted to serve pilgrims even more directly than they did in the past. The church of La Trinidad at Sahagún, in the province of León, for example, has been ingeniously redesigned as a *refugio*. Others, like San Juan de Ortega (in the province of Burgos), seen here in its valley of nettles (*ortegas*), thrive, in their own way, literally amid the ruins of their former glory. Some of the old dormitories of San Juan now comprise one of the best-known *refugios* along the way, one that is especially recognized for the successful attempt by the local priest to revive the spirit of the pilgrimage in a nonproselytizing way. The priest of the twelfth-century church of Santa María del Camino in Carrión de los Condes (in Palencia) housed large numbers of pilgrims in one of the old buildings of the churchyard for years; a new *refugio* has recently been created from a renovated older building nearby. And the British Confraternity of Saint James, a secular pilgrimage organization, bought and beautifully restored a fifteenth-century parish priest's home in Rabanal del Camino (in León) to serve as a *refugio*; not only was this along one of the most difficult stretches of the Camino to find lodging, but the popular new *refugio* has been a significant factor in the economic revival of the small mountain village. PHOTO: LOTHAR VON FALKENHAUSEN

► The experience of hiking toward such a dramatically sited castle as Castrojeriz, about a day's journey west of Burgos, once the capital of Castile, is not what it may seem. To see or visit a truly imposing castle ruin is one thing. But, for a person with a historical imagination, to trudge toward it for the better part of a morning and along the base of its hill and away from it for much of the afternoon goes well beyond the usual historical descriptions in guide books in conveying the historical depth of the violence of the region he or she is trudging through—even of the region of Castile, which takes its name for the many castles there, castles that were built at great expense for a very good reason. As hour after hour brings the awed pilgrim only one step closer at a time—feeling smaller with each one of those steps and with very little else to look at as he or she moves on—it is only too easy to imagine the vast outerworks of the many fiercely contested sieges that this massive and seemingly impregnable castle withstood, or didn't, during the two to three thousand years during which it dominated the people and land around it. It is only too easy to imagine the enormous effort it must have taken to incite so many thousands of heavily armed men up the steep and rocky hill so many times, there to confront so many desperate and equally well armed defenders, to breach the walls, to fight their way in, and—in any number of different ways—to bring the undertaking to a close. Perhaps it was just this dramatic siting that led people of earlier times to claim that Castrojeriz had been founded by the great Roman general Pompey or by Julius Caesar. In fact, so violent is the history of this region that the site had been taken and destroyed many times before these Romans ever came to Spain. PHOTO: LOTHAR VON FALKENHAUSEN

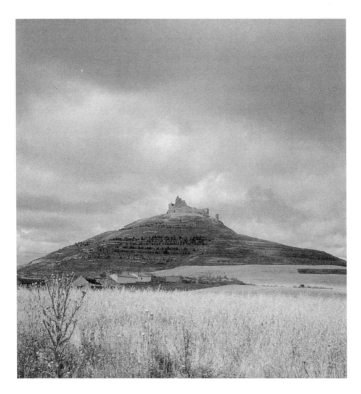

► One of the medieval meanings of the word "pilgrim" is that of an exile on this earth, and nowhere does the long-term pilgrim feel as if he or she were an exile more than in the great sun-and-storm-beaten Meseta of northern Spain, passage through which is one of the pilgrimage's essential defining moments. In this place, seemingly devoid of people or human habitation outside of its small and very circumscribed towns, the pilgrim feels at the complete mercy of the sun, the wind, and the rain—which, along with the wretched earth on which the exhausted pilgrim rests, make up the four elements of nature in the medieval sense—with no one and nowhere to turn to for relief. For me, it was especially here that the pilgrimage took on the feeling of a permanent way of life, due in part, no doubt, to the featurelessness and unchanging aspect of this place to which I came to be inexplicably drawn. PHOTO: LOTHAR VON FALKENHAUSEN

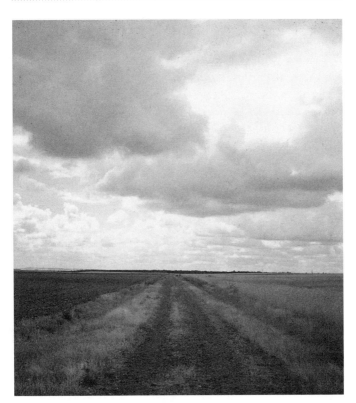

▶ The Cruz de Ferro, which marks the pass at Monte Irago through the Montes de León, a spur of the Cantabrian Mountains, has been described as the most ancient monument of the Camino de Santiago. The heap of stones that has been built up here is believed to have been begun by the ancient Celts and continued by the later Romans, both peoples who marked such liminal sites. The thoroughly pagan monument was Christianized in the twelfth century, at the height of the pilgrimage, by a local hermit, Gaucelmo, through the raising of a cross on top of it—something that seems to have done nothing to stop the practice of adding stones to this living monument by those passing by. PHOTO: DAVID HERWALDT

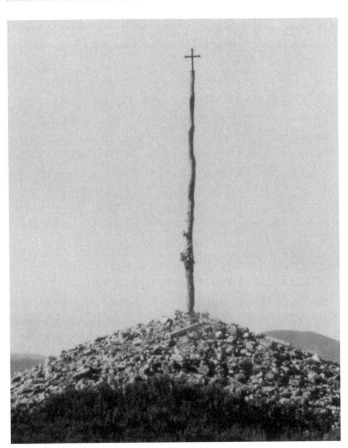

▶ If I or my friends had had the brashness—and the instantaneous reactions it would have taken for this almost split-second encounter—you would see a picture of a Spanish farmer, deep in the hills of Galicia, the middle of whose farmyard the pilgrimage trail runs right through, with eyes seeming to glow with unbounded resentment from his ancient and malevolent face like sluggish red embers, only half-hidden in the back of his centuries-old stone barn, which gave the impression of never having been shoveled out during its existence, hanging with scores of antiquated tools and bits of broken harness, all too old and worn to ever be used again. Was he, perhaps, one of those people whose faces suddenly change to kindness when spoken to, or was he something else, like a timeless character out of an unsettling folktale? We kept walking, eyes front.

PHOTO: LINDA STEARNS

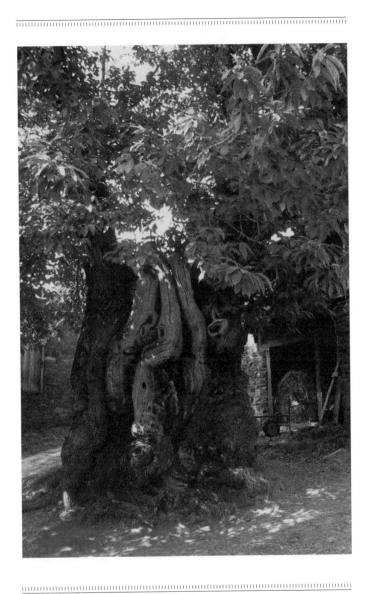

► A magnificent sight after two and a half months of walking, the west façade of the Cathedral of Santiago announces to the expectant pilgrim that he or she has indeed arrived. The extravagant late-baroque exterior, the result of several building projects in the seventeenth and eighteenth centuries, encases an essentially complete medieval church within—not so dissimilar, perhaps, from the way the essentially medieval pilgrimage continues today within a modern context of automatic teller machines, cell phones, and hot showers. As I sat waiting in the crowded church for the next in a series of extraordinarily lavish ceremonies celebrating the Feast of Saint James, it struck me that the cathedral had a quality I have noticed in only a few other great buildings around the world, such as Saint Peter's in Rome or the U.S. Capitol in Washington: it is a truly *public* building, one in which people who are not church members or citizens can feel that they are nonetheless not outsiders. There was none of the hushed and tip-toeing attitude of visiting a museum so common in most other great churches. Witnessing the modern equivalent of the descriptions of the cathedral from the twelfth century, I was especially struck that every sort of person was drawn to this building—though no longer "the blind, those missing hands . . . those bound with iron chains," and so on. Here, a heavy Spanish woman sat in the middle of all the frenetic activity of the dazzling cathedral drinking a Diet Coke, as at ease as if she were slouching on an old couch in her own home. There, a drunk and snickering Scandinavian teenager paraded by, self-consciously smoking a cigarette in the church and ostentatiously flicking the ashes on the floor, desperately hoping his studied irreverence would attract attention, perhaps even secret admiration. Through a side door, a busload of German tourists—probably Lutherans—sheepishly stumbled through, darting timid glances around, looking

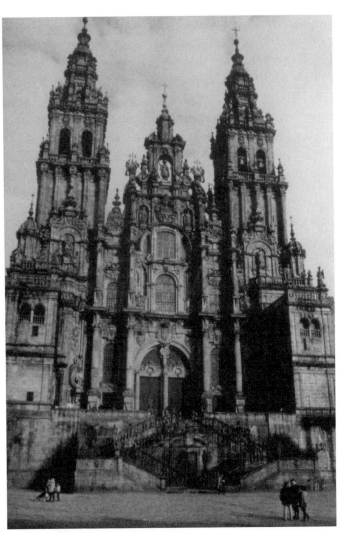

as if they were afraid the pope himself might jump out from behind a column and force them into communion with Rome against their will. Everywhere, the church was packed with people praying, laughing, looking, talking, and waiting expectantly for the next stunning ceremony. PHOTO: DAVID HERWALDT

▶ The south transept portals of the Cathedral of Santiago are known as the Puerta de las Platerías, the Portal of the Silversmiths, so called because the silversmiths who catered to the pilgrim trade had their shops on the plaza facing it for many centuries. They were heavily damaged in 1117 in riots in which the people of Santiago were prevented from killing their bishop in his own cathedral only by a ruse on his part worthy of a Hollywood film. After years of simmering antagonism, the people rose up against the bishop, who ruled the town, attacking him in the cathedral, setting it on fire, and forcing him to take refuge in one of the towers, which they also set afire. An abbot from one of the monasteries in the city was allowed by the mob to enter safely in order to hear the bishop's confession—his last, they assumed. Hedging his bets, the bishop both made his confession and used the opportunity to disguise himself. Then, holding a crucifix over his face, he sneaked out with the abbot's party when they were allowed to leave—boldly walking unnoticed through the middle of three thousand raging rebels, all of whom wanted only one thing: his blood.

The portals open today onto a pair of stately plazas that are an important part of the very active public life of this beautiful city. For almost nine hundred years, both jubilant pilgrims and the simply curious have passed through them, and, for just as long, beggars have begged in front of them. PHOTO: EDILESA

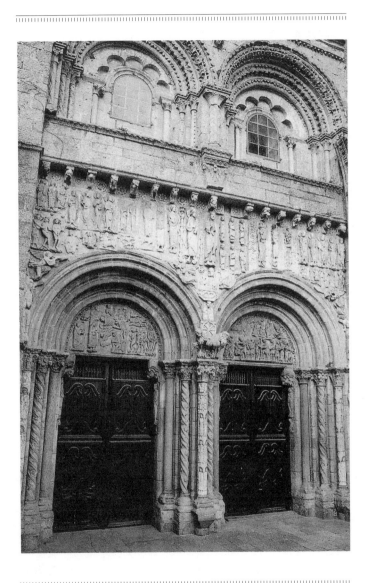

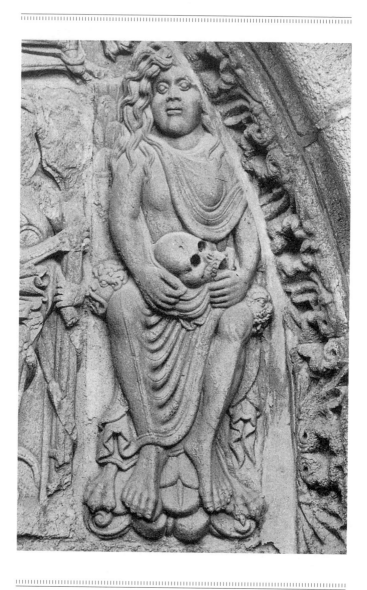

◄ The author of the twelfth-century *Pilgrim's Guide* writes about the half-naked woman of the Puerta de las Platerías—apparently told this story on the spot by a local—"Let us not forget a certain woman . . . who holds between her hands the stinking head of her lover that her husband has cut off, and that he forces her to kiss twice a day. How such great and admirable justice for an adulterous woman should to be told to all!" PHOTO: CLAUDE SINTÈS, MUSÉE DE L'ARLES ANTIQUE

▼ Finisterre, the End of the World. PHOTO: LOTHAR VON FALKEN-HAUSEN

DOING
THE PILGRIMAGE

The pilgrimage to Santiago is a journey like nothing else you've ever done. On this journey, every day has the potential of presenting something completely new. In order to be receptive to this experience, the attitude of the pilgrim has to be free, spontaneous, unstructured. The pilgrimage is not free of contradictions, however, and one of its many little ironies is that the first step toward this state entails a certain amount of very practical preparation ahead of time. It doesn't take much, but it must all be done.

The Route

The pilgrimage to Santiago can begin from anywhere. But on the basis of the twelfth-century *Pilgrim's Guide* (see the Suggested Reading below for an English translation from the medieval Latin), there are said to be four classic starting points.

While modern guide books exist for all four routes, by far

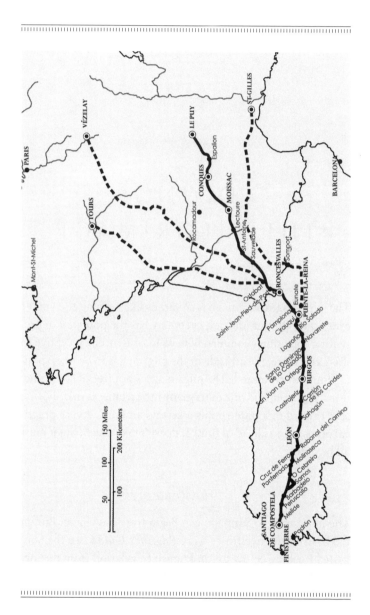

◄ Although a medieval pilgrim from north of the Pyrenees might follow any route he or she chose to Santiago, the twelfth-century *Pilgrim's Guide* tells us that pilgrims traditionally followed four main routes, all of which eventually joined in Spain at Puente-la-Reina. The exact roads were based on a combination of simple geographic logic and the strength of attraction of whatever holy places happened to be in their general vicinity. Sometimes they took advantage of the Roman and medieval road systems, and at other times they completely disregarded the practical in pursuit of the sacred. The Le Puy to Santiago route is indicated by a straight line, the other three traditional routes by dashed lines. MAP: CLAIRE CLEMENT

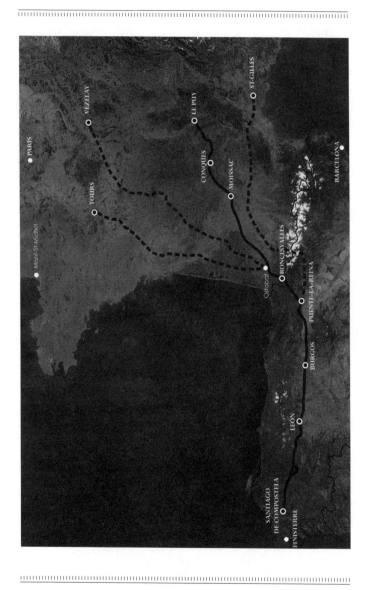

◄ A satellite image of the pilgrimage routes provides a little reality check to the bland abstractions of a traditional map. But even this isn't enough to convey the toughness of the trail. The daunting mountain ranges of the Pyrenees and the Cantabrians speak clearly enough of the great challenges the pilgrim must overcome. But the lower elevations of Gascony, just north of the Pyrenees in southwestern France, appear fairly tame from five hundred miles up when, in fact, their broken ground can, at times, be as demanding as any of the more visibly imposing trials of the way. IMAGE: NASA/CLAIRE CLEMENT

the most beautiful is the one from Le Puy, in the heart of the Massif Central. It's also the route with the best-preserved pilgrimage churches from the Romanesque period and the one taken by the vast majority of pilgrims today. This is the route that I took and that I have in mind when I describe the pilgrimage.

The entire pilgrimage from Le Puy, in south-central France, to Santiago, in northwestern Spain, is around a thousand miles (sixteen hundred kilometers) and takes about two and a half months. This includes getting to Le Puy, the occasional rest day along the way (I had rest days at Conques, Moissac, Burgos, and León because of their interest), a three-day hike beyond Santiago to Finisterre, a day or two at the celebrations of the Feast of Saint James, and the return.

It's my personal belief that some of the sensations I describe in the second chapter, "The Pilgrimage to Santiago and to the End of the World," are experienced only with more than a month of walking (that is, more than just the Spanish route). Very few people, however, can manage such a long trip. Most people walk a small part of the way, usually on the Spanish route (typically finishing at Santiago), although other parts of pilgrimage route are done as short walks as well.

A popular yet more challenging alternative is to undertake all of the Spanish route—called the *camino francés* because so many French pilgrims took it in the Middle Ages—at one time, typically beginning at Saint-Jean-Pied-de-Port or Roncesvalles. If you choose to do this, I recommend beginning at Saint-Jean (on the French side of the border) rather than at Roncesvalles (on the Spanish side), so that you will have the experience of crossing the Pyrenees.

Still others do all of one of the "classic" pilgrimage itineraries—such as that of Le Puy to Santiago—but in shorter segments, breaking the entire trip down into however many parts

they have the time and energy for. For example, some who do the Le Puy to Santiago route by these still demanding segments break it down into France and Spain, with the French leg being a little over four weeks and the Spanish a little over five.

Those who are really pressed for time—that is, almost everyone—but who nevertheless want to walk all of the "classic" Le Puy to Santiago route further break down each of the longer legs into two, for a total of four segments of roughly two and a half weeks each. For example, the first segment might be from Le Puy to Moissac (around halfway from Le Puy to the Pyrenees). The second segment might be from Moissac to Roncesvalles (the first Spanish town after crossing the Pyrenees, and about halfway from Le Puy to Santiago). The third might take the pilgrim from Roncesvalles to León, one of the great cities of Spain (around halfway across Spain from Roncesvalles). And the fourth might be from León to Santiago—and for the truly obsessed, beyond Santiago to Finisterre.

These four segments more or less correspond to the four main geographical regions of the Le Puy to Santiago pilgrimage route.

The Le Puy to Moissac segment leads through one of the most beautiful parts of Europe, the Auvergne and the Lozère, as stunning in their own ways as the most magnificent parts of Wyoming and Colorado. Except for the occasional village, you may travel for days through the high plateaus and herds of grazing sheep and cattle without seeing more than a handful of people. Along the way, you might stay at the twelfth-century Knights Templar grange of Le Sauvage; visit Conques, one of the most evocative Romanesque pilgrimage monasteries in France; see any number of enchanting villages you've never heard of before and never will again; and wind up at Moissac, a few days out of the Massif Central, where the greatest extant Romanesque sculpted cloister survives intact. Food is one

of the great experiences of travel, and the food in this region is exceptional.

The Moissac to Roncesvalles stretch sticks out in my mind as the most challenging part of the whole pilgrimage. Running mostly through Gascony, I thought it had both the most difficult geography—a rough and sometimes wild region of low, rolling terrain—and people among the most receptive to pilgrims of the entire trip. Once in a while there may be problems finding a place to stay on this stretch. But this is all part of the fun—like stopping at Saint-Antoine, a little town with no hotel, no restaurant, no café, and no stores, only an unattended *gîte,* where a woman about thirty-five years of age cooked us dinner at her home and brought it to us for no apparent reason other than that someone had to do it; in clothes, manner, personal appearance (disarmingly beautiful), and mode of transportation (Volvo station wagon, of course), she would have fit right in in my hometown of Brentwood, California. Saint-Jean-Pied-de-Port—with its quaint old church and winding streets made festive with window boxes of bright, colorful flowers—is the last town on the route in France and an old pilgrimage and mountain-pass trading town very picturesquely situated at the mouth of the pass of Roncesvalles. It is from here that the pilgrim begins the ascent of the Pyrenees, an experience not to be forgotten. (Be sure to take the ancient upper road that goes over the mountains, not the easier one that runs through the bottom of the pass.) Shortly after the summit, the descent leads to Roncesvalles, one of the greatest of the old pilgrimage monasteries and the legendary place of the death of the epic hero Roland. Just over the Spanish border, in the very heart of the Pyrenees, lies Roncesvalles, shrouded in both fog and time.

In sharp contrast, the weary pilgrim is energized by the urban air of Pamplona, only a few days out of the mountains

on the route from Roncesvalles to León. In this sophisticated regional capital, the whole city seems to come out at night to stroll the ancient but very fashionable and lively center of town. This is Basque country, and it is noticeably different from what you will encounter before and what you will encounter after it. The pilgrimage route in general is lined with the ruins of the past, but nowhere are they more plentiful and fascinating than on this stretch—something that in no way is made any less interesting by the fact that this part of the route runs through La Rioja, the most famous wine-producing region of Spain. It can be a bit hot in Spain in the summer, especially along the stretch of the route from Burgos to León. But the rich historical layering of this segment of the pilgrimage route more than makes up for it. This is the country of El Cid, and both Burgos and León are among the great cities of Spanish history and culture, with stunning cathedrals, great urban architecture, fine museums, and marvelous food. It is also the heartland of the pilgrimage, with long stretches of sun-beaten trail straggling across the Meseta, the famous tableland of Castile and León, and here the pilgrim finds out just what the pilgrimage is all about.

One thing that makes the pilgrimage different is the attitude toward it of the people who live along the way. Whether the eccentrics who live in the hills and who have devoted their lives to the pilgrimage, or simply the wonderful Spanish people, the last segment, León to Santiago, has them in droves. This largely mountainous segment, which begins toward the end of the Meseta, is one of the regions of western Europe least touched by modern times and among the most beautiful of the entire trip. Two of the great stops here are Rabanal del Camino and O Cebreiro, both situated on the ridges of mountain ranges that must be crossed. At Rabanal, the pilgrim is greeted by one of

the most welcome *refugios* of the trip, a fifteenth-century house beautifully restored and run by the British Confraternity of Saint James. And it may have just been my frame of mind at the time, but O Cebreiro seemed to be a very special place, both for its general feeling of existing in another time and for the fact that I seemed to run into interesting people one after another.

The wise pilgrim plans the trip so that he or she will arrive in Santiago a few days before the feast day of Saint James, July 25. The city virtually explodes with activity for several days previous, culminating in a great spectacle in the plaza in front of the cathedral on the eve of the feast day. During all this time, the city is alive with fireworks, parades of *gigantes* and *cabezudos* (giant puppets), plays, people running around in costumes, and every kind of music imaginable, including Spanish Celtic folk music, in which the bagpipe is a central instrument and which is perhaps most easily described as the Galician counterpart to traditional Irish Celtic music. (This part of Spain, Galicia, is an old Celtic region.) One of the most popular events of the elaborate half-week of festivities is the swinging of the centuries-old, solid silver censer called the *botafumeiro*.

The trip is not really complete, in my opinion, without the final three-day journey on foot to Finisterre. This was where in ancient times the known world reached its westernmost extent, and the destination of a pagan pilgrimage from which the Christian pilgrimage to Santiago took its symbol, the scallop shell. It's also a place of astonishing beauty.

For those who do the long-term pilgrimage, and even for those who do the shorter segments, the length and difficulty combine with the special treatment given the pilgrim to create an experience unlike any other. Yes, it's difficult to find the time and money, and even more difficult to do. But for those who want something more, you'll find it on the long, hard trails of the pilgrimage to Santiago.

Getting There

WHO The pilgrimage can be done by anyone who likes to walk. The ages of the pilgrims I saw, both men and women, ran from around eighteen to the late sixties. One long-term female pilgrim was seventy. The vast majority of long-term pilgrims were in their forties, fifties, and sixties. It was only toward the end of the route that large numbers of younger pilgrims began to appear, pilgrims who were by definition short-term.

WHEN Once you think you would like to make the pilgrimage, the first thing to do is determine what arrangement of segments works best for you. The second is to decide when you are going to do it. May and early June have the best weather, but those who want more company would prefer the second half of June and July or even August, when it's a bit warmer but the trails begin to fill up (as do the *gîtes* and *refugios*). The Santiago stretch should by all means be coordinated with the Feast of Saint James, July 25.

TRAINING It's mandatory to wear only fully broken-in boots and a good idea to begin modest training with a loaded pack at least a couple of months ahead of time. Pack what you need (including one filled $1\frac{1}{2}$ liter water bottle and what food you would have for lunch), weigh it, and replace the weight with old phone books, sand in plastic bags, dried beans, or whatever seems to work without damaging your pack. Then find a good place to hike. Gently rolling terrain and rocky trails would be best, though this is a minor point.

Start off with an hour or two once a week and work your way up to four to six hours a day just before leaving. I won't say how much I trained since it was ten years between the time I decided to go and when I actually was able to set out, but

when the real thing began I was very glad I had. I also made it a rule to train in all types of weather, including in the rain and on days over 100°F (38°C); you should do this, too, so you know what you are in for. Training without a loaded pack and boots is worse than pointless since it may lead to expectations that bear little resemblance to the reality of the road.

It is through this process that you begin to develop a sure balance, get to know your pack, break in your boots, and avoid the very unpleasant experience of having to drop out after a few days and go home, as quite a few people I ran into did.

GUIDES A number of guides are available, and all of those listed here are good. All have maps and list distances, places to stay, stores, cafés, museums, and so on. But they present this information in different ways, and each has its own particular advantages.

The only single volume that will guide the pilgrim all the way from Le Puy to Santiago is Alison Raju's *The Way of St. James: Le Puy to Santiago, A Walker's Guide* (Milnthorpe: Cicernone Press, 1999). This has very good directions and advice, the result of much experience from a person who knows the road well. Most guides present the route in the form of suggested daily stages—a practice that often results in a bunching up of pilgrims at the hostels listed at the suggested day's end while leaving those in between these suggested stages relatively unused. Raju simply gives the distances between points along the way (citing hostels as well as other information), an approach that both encourages independence on the part of the pilgrim and helps to prevent unnecessary overcrowding. Unlike most other guides, this one gives the route to Finisterre, which was very poorly marked when I did it. Although Raju does mention historical monuments and other points of historical and cultural interest that occur along the way, she emphasizes this very

important part of the experience less than others do. The sketch maps work perfectly well, although there is no topographical component, something many pilgrims like. The book is relatively small and light, a distinct advantage over most other guides.

From Saint-Jean-Pied-de-Port to Santiago, Millán Bravo Lozano's *A Practical Guide for Pilgrims: The Road to Santiago* (León: Editorial Everest, 1998) is excellent. This guide presents the route in terms of suggested stages, although the author lists other *refugios* in between, and the pilgrim is by no means obliged to follow this exact staging. I used this guide—often following my own stages—and appreciated the brief but good presentation of historical information, not to mention the fine color photographs. This guide is, however, a bit heavy and awkward, and its sketch maps, while perfectly usable, have only a slight topographical suggestion.

The Confraternity of Saint James has a series of guides, many of which are updated yearly. The confraternity's philosophy regarding the pilgrimage is admirably inclusive, and it offers small, lightweight publications for historical pilgrimage routes to Santiago from every conceivable direction. Following the traditional four routes from the north, they have guides from Paris (the Tours route), Vézelay, Le Puy, and Arles (the Saint-Gilles route), all to the Pyrenees or a bit beyond. Their guide for the Le Puy route is by Alison Raju, *Le Puy to the Pyrenees* (London: Confraternity of Saint James, 2002). The confraternity also provides a series of historical routes from points south of the Pyrenees to Santiago (Portugal, Seville, and Madrid), some northern coastal routes, and a number of others as well. Its guide for the Spanish segment of the route discussed in this book is David Wesson's *Camino Francés,* a publication that is updated every year. For a complete listing of confraternity publications (including a number of admirable

historical publications as well as some guides by other publishers), see the section on organizations (p. 130) and check out their Web site.

There are quite a number of guides for French, German, and Spanish readers. Louis Laborde-Balen and Rob Day's *Le chemin de St-Jacques du Puy-en-Velay à Roncevaux* (Ibos-Tarbes: Randonnées Pyrénéennes, 1995) is very good, with a fair discussion of historical sites. It has both sketch maps with a topographical component and actual topographical maps. The same authors have also written a guide for the historical route from Arles through the Somport Pass (the Saint-Gilles route) and one for the Camino through Spain from Saint-Jean-Pied-de-Port to Santiago (both also published by Randonnées Pyrénéennes). The best guide available for Spain is in German: Michael Kasper's *Jakobsweg* (Kronshagen: Conrad Stein Verlag, 2003). It provides both practical and historical information, has reasonable maps, and gives locations of important facilities, the hours of museums, and so on; it is revised regularly, and, unlike many other guides, is designed to be carried. Millán Bravo Lozano's English guide is translated from the original Spanish: *Guía práctica del peregrino: El Camino de Santiago* (León: Editorial Everest, 1998); this excellent guide is also available in French and German.

Architects, art historians, and those who are just interested in architecture might want to look at Michael Jacobs's *Road to Santiago de Compostela* (in the Architectural Guides for Travellers series put out by Penguin Books, 1991).

Most of these guides are regularly updated and republished, so look for the most recent edition available.

A good bookstore or Internet site should be able to order any of these for you. An exception seems to be the guide by Millán Bravo Lozano, which can, however, be ordered in the United States through Old Manuscripts & Incunabula, P.O. Box 6019,

FDR Station, New York, NY 10150 (http://www.mpa.org/agency/441p.html).

THE PILGRIM'S CARD AND COMPOSTELA A pilgrim's card, or *credencial,* is a necessity for serious pilgrims. It allows you to stay at the *refugios* (some *gîtes* also require them) and serves as the documentation required to receive the Compostela or certificate of completion of the pilgrimage when presented at the Oficina de Peregrinos, 1 Rúa de Vilar, in Santiago. It must be stamped once daily, normally at the *gîtes* and *refugios* themselves, though some cafés and historic churches also stamp the cards. A card can be obtained free of charge by writing the Friends of the Road to Santiago (but send them at least ten dollars, anyway, to help defray costs; see the section on organizations, p. 129, for address, Web site, etc.) or at the *refugio* at the abbey of Roncesvalles (for a charge of one euro). A minimum of the last hundred kilometers (around sixty-three miles) of the Camino must be walked on foot to earn the Compostela. (Sarria, in the province of Lugo, would be the starting point for a hundred-kilometer pilgrimage; anyone who begins as near as Lugo is required to have his or her card stamped twice daily.)

LODGING Serious pilgrims normally stay at inexpensive hostels called *gîtes* in France and *refugios* in Spain, which are an important part of the pilgrimage experience and the best way to meet other pilgrims. *Gîtes* are owned either privately or by the local government and run anywhere from two to ten dollars a night, depending on what type of *gîte* it is and whether dinner and breakfast are part of the arrangement. *Refugios* are normally owned by an organization such as Los Amigos del Camino de Santiago (the Spanish pilgrims' association), the local government, a church, or a monastery. *Refugios* associated with Los Amigos are staffed by volunteers from all over

Europe and the United States who typically give up their summer vacation to be part of the pilgrimage. The British Confraternity of Saint James and the Italian Confratèrnita di San Jacopo di Compostella di Perugia have also restored and operate their own *refugios*. *Refugios* usually run from a dollar and a half to four dollars a night, though some are free or ask only for a modest donation (give three or four dollars). In most *refugios*, a stay of only one night is permitted, unless the pilgrim is sick.

All pilgrim's guides have listings of these hostels, and, with minimal planning, there is rarely any trouble finding one. Some pilgrims race ahead each day to be sure that they have beds, typically at those *refugios* found at the day's end of guides that give suggested stages. Don't get in the habit either of racing ahead or of rigidly following suggested stages; be aware that there are many hostels all along the way, especially in Spain.

As a rule, the hostels run from good to very good, with a number being exceptional (given that pilgrims' hostels are, by definition, very modest to begin with). Every hostel I stayed at was clean and had hot showers. Normally, men and women sleep together in the same room in these hostels, usually in bunks.

MEALS Most pilgrims buy breakfast and lunch at the day's end for the following day, since it is usually impossible to find places for breakfast open early enough in the towns or to find anything at all for lunch out on the trails.

Many *gîtes* and *refugios* have furnished kitchens where pilgrims can cook dinner, something I would never do: food is an important part of the experience and a proper dinner is a necessity, especially for those beyond college age. Almost without exception, local places to eat are found along the whole route, with the fare ranging from the hearty and plentiful to the truly

exceptional. At the end of a long day, it restores the weary pilgrim to sit down somewhere other than the dirt of the roads for a good dinner and a bottle of wine.

In the smaller towns in France, always ask at the *gîte* how the local restaurant operates: several times we had to order dinner as soon as we arrived in the afternoon, with the restaurant opening only to serve dinner to us. In cases like these, there was no menu selection since the cook simply made what was already at hand. For some reason, these dinners often turned out to be the most fun. Houses with rooms to let and even a regularly open restaurant may (though very rarely) also follow this practice.

Spanish restaurants often open only at 9:00 P.M. or even later, though some do open a bit earlier. This sometimes creates a small problem because of curfews at many *refugios*.

I had to eat around twice what I normally do in order not to waste away, although this would not be the case for everyone.

THE DAY In most *gîtes*, travelers get up whenever they want. In *refugios*, they are often expected to be up and out by 7:00 A.M. We usually got up around 6:15, washed, got packed, had breakfast (bought the day before), and were on the trail by 7:00.

Trails in France are marked by a rectangular symbol with two horizontal bars, red above and white below. Follow the map and directions in your guide very closely in France, where the same marking is used for criss-crossing trails! In Spain, way markers change from province to province, but they usually follow some unmistakable variation of a yellow arrow. It's almost impossible to get lost in Spain unless the Galician fog completely envelops you.

Some people like to rest for a few minutes every hour while

walking; we preferred one longer break (ten or fifteen minutes) at mid-morning and another at mid-afternoon, having a little something to eat at each break. We had a slightly longer rest at lunch (thirty minutes or so, after eating). Be sure to take off your boots and socks to air-dry at *each* break! It reduces moisture and therefore the chance of developing blisters. This simple practice is one of the most important things you can do to avoid problems with your feet (and, unfortunately, one I learned only after having caused a lot of unnecessary damage).

A normal day for long-term travel with a pack is around fifteen miles (around twenty-five kilometers), although this will vary considerably in practice. Without going to extremes in either direction, a pilgrim can expect to walk anywhere from twelve miles (nineteen kilometers) to twenty miles (thirty-two kilometers) a day. The longer distance is the more common experience.

Although you might arrive at your destination at any time of the afternoon or early evening, it's usual to reach it by around 3:00 or 4:00. Most people immediately shower, hand-wash their clothes, hang them up to dry (often no small feat, unless you bring your own cord and clothespins), rest a bit, and then find a store for the next day's breakfast and lunch before having dinner. I always had a long look around wherever we stayed. Many *refugios* have curfews of 9:30 or 10:00 P.M.

FEET AND KNEES You can't do the pilgrimage if you can't walk. Be very sure to take good care of your feet and knees. I saw many would-be pilgrims drop out because of a completely unnecessary lack of attention to this basic imperative. Along with airing your feet, socks, and boots several times a day, there are a few other simple things to pay attention to at all times.

It's important to put socks on very carefully, so that there are absolutely no wrinkles, another main cause of blisters.

Start off with well-waterproofed boots, and keep them properly waterproofed along the way. This will help cut down on moisture and so on blisters, and is worth the weight and trouble of carrying waterproofer and using it.

When you have a blister or some other sore, take care of it properly and immediately. I used moleskin in places where a blister seemed as if it might develop and where I had other types of friction problems, such as hot spots. Once a blister appeared, I washed the area well with soap (at the shower at the end of the day), pierced it with a safety pin sterilized with a match, and rubbed in a little disinfectant. (I kept the safety pin pinned to a place where it wouldn't get lost.) Never peel off the old skin. If a blister is seriously affecting either your enjoyment of the day's walk or your ability to do it, stop and pierce it right on the trail, soap or no soap. When friction points got really bad (for example, repeat blisters on the same spot or unusually severe blisters), I was very glad to have a product called Second Skin. It can make the difference between an enjoyable walk and one of unremitting suffering.

Also, it is very important to keep your toenails well trimmed: not too short and, most definitely, not too long (especially for the big toes). I saw serious foot problems caused by not taking care of this very simple matter.

It became horribly clear to me on the very first day of my pilgrimage that my knees might not take me a second, let alone another seventy-three. The immediate cause was the weight of the pack when walking on—and especially down—deeply gouged and rocky trails, which means almost all of them in France and in the hills of Spain (I had practiced on smooth trails at home). As I sat in the charming French country inn in which we had been forced to take shelter from a violent rainstorm sometime after the sun had gone down, at a complete loss as to what to do, my fellow pilgrim, Eric Doud, took a neoprene

knee brace (the kind joggers often wear) out of his pack and handed it to me, something for which I have been grateful ever since. Oblivious to such things in the past and doubtful about it at the time, I wore it the next day, and the next, and the next, and so on for the next two and a half months to Santiago. Many people have kneecaps that are slightly out of line, and the brace simply encourages the kneecap back to where it should be in the first place (as I was told by another pilgrim I later met, a Dutch medical doctor). I soon got a second brace for the other knee—they should be snug but not tight—alternating them, turning them inside out, and letting them dry out like socks when I took a rest. My knees had become so stressed that I had to wear the braces even when I wasn't carrying the pack, such as when I was shopping or going to dinner at the end of the day. I continued to need to wear them for about a week after I had completed the pilgrimage, but my knees seemed to work well enough after that. If you walk with a full pack for a couple of six-hour days before leaving, you should know whether or not you need these. It's not for me to give medical advice, but I couldn't have done the pilgrimage without them.

LANGUAGE Not knowing French or Spanish shouldn't keep you from doing the pilgrimage. However, before you go, you should get a phrase book of whatever language you will need. Study it, identify the crucial phrases and vocabulary, write these down on a piece of paper, learn them, take the paper with you, and leave the phrase book at home (it's just extra weight). Useful phrases include "Where is . . ."; "I would like . . ."; "How much is . . ."; "I would like to spend the night"; and so on. Useful words or expressions include "hello," "good-bye," "please," "thank you," "you're welcome," numbers, and general vocabulary for travel, directions, restaurants, the grocery store, hostels and hotels, and so on. Work it out for yourself.

It's minimal, it's part of the fun, and you should consider it mandatory. The people along the way are very sympathetic and forgiving of bad French and Spanish, but you must meet them halfway.

What to Take

The pilgrimage begins with the right boots. Because you are carrying a pack, the right boots for a long-term pilgrim are medium weight with full ankle support; they should have strong, stiff soles for the very rocky trails and Gore-Tex liners, and they should be fully broken in before leaving. I like full leather tops for the important protection they provide; others prefer combination leather and mesh tops for their ability to breathe (though I've been told that they lose this ability once the fabric clogs up with dust and mud, which happens almost immediately). When buying boots, be sure to try them out on a downward slope of around 30 degrees (the better sporting-goods stores should have a little platform specifically for this purpose). The point is to be completely sure that the ankle support prevents your toes from slamming into the toe of the boots, something that would put an end to your pilgrimage very fast, with all the uneven terrain a pilgrim travels through. Short-term pilgrims can get by with good lightweight boots, which can be excellent, being both lighter and cooler than medium-weight boots. This is because the long-term pilgrim's feet eventually become extremely sensitive to the almost constant pounding of the feet on the sharp stones of the trail, which most short-term pilgrims do not walk long enough to experience.

The goal with selecting (and using) your clothing is to gain as much control as possible over the elements: heat, cold, wind, and rain. This is best achieved through a triple layering of relatively light and very specific materials, worn in the particular

combination of T-shirt (inner layer), sweater (middle layer), and windbreaker (outer layer). Anything worn on the upper body, except the T-shirt, should have a fully zippered front in order to provide better control over warmth, cooling, and perspiration. Depending on weather conditions, the wise pilgrim orchestrates all possible combinations of these three—T-shirt, sweater, and windbreaker, all discussed below—to avoid making things any more difficult than they need to be.

For most of the inner layer (T-shirts and underwear), use all-cotton only (it's my feeling that synthetics are not right for the hot trails of southern France and northern Spain). For everything else, you will unquestionably be better off with a combination of blends and synthetics. For socks, blends specifically designed for hiking (for example, a wool, nylon, and Lycra blend) eliminate the need for inner and outer socks; you will appreciate this when you wash them by hand, struggle to find a place to hang them, and wait for them to fully dry every day. (Some people may need two pairs of socks at a time anyway; find out as you go through the training process and act accordingly.) Avoid white in everything you take; it will immediately become dingy with the daily hand-washings. For T-shirts, underwear, and socks, you can get by with only two sets of each if you wash every day without fail; otherwise, bring a third set. (I took a third pair of socks because they are so important, and would do so again.) If you are especially sensitive to the sun, you might want to consider long-sleeved T-shirts; however, even though I'm very fair, I got by fine with short-sleeved shirts and sunblock and would find long sleeves too warm for most hiking in France and Spain in the late spring and summer. Men will need a third set of T-shirt and underwear to use as pajamas (remember, men and women usually share the same room in the hostels); with this charming outfit, I was quite decently dressed by pilgrimage standards. Women dressed sim-

ilarly at night, the main difference being that the T-shirt most wore extended to a few inches above the knees.

A fully zippered poly fleece sweater (middle layer) and Supplex nylon or Gore-Tex windbreaker (outer layer) are a great combination: the sweater keeps you warm and the windbreaker helps shield you from the wind and water, which reduce warmth. The windbreaker should have a hood, since your cotton hat will do very little for you in the rain aside from keeping it from hitting you in the face and, in any case, won't keep it from running down the back of your neck. This question of protecting yourself against the rain is a tough one. Those who can afford a Gore-Tex windbreaker will have a waterproof windbreaker. Those who use a less expensive Supplex one (water-resistant only) might want to consider a poncho for additional protection. Ponchos cover the hiker and the pack, and can be used as ground cloths, but they tend to be heavy, and my experience—a common one—is that I was just as wet under the poncho, because of its inability to breathe, as I would have been if I hadn't used one at all (though it does keep the cold rain off). If I were to do it again, I would get the Gore-Tex, leave the poncho at home, and take my chances without a ground cloth.

Speaking of ponchos, new packs are water-resistant (but not waterproof), and an older one can be made water-resistant. Instead of a heavy poncho or pack cover to protect the pack, I'd do what some pilgrims do: use a large plastic trash bag, which is very light and compact (though easily torn). However, if you do have to sleep on damp or wet ground, you might wish you had a poncho to use as a ground cloth. It's an individual choice.

I recommend an external frame pack of medium size (no larger) with adjustment or load lifter straps (part of the shoulder-strap system). An external frame pack will keep the pack off your hot and sweating back and allow air to circu-

late between you and it. The more common internal frame pack gives a bit better balance but will allow no air circulation—and will be regretted almost immediately on the hot and humid trails of France and the even hotter and dry trails of Spain. Aside from the external frame, important features are load lifter straps (to pull the weight in just a bit more; it made all the difference in the world to me), a mesh back-band (for comfort and cooling), and a good waistbelt (to let the weight ride on your hips). I took a superb pack, but at 4,900 cubic inches (about 80 liters), it was too large. I recommend something around 3,900 cubic inches (about 64 liters), since you won't be carrying food supplies beyond the day's lunch. The Kelty Trekker 3900 ST is excellent (leave the removable top bar at home; you won't be needing either it or the extra weight). Your pack is not something to economize on: stop and think about how much you would pay for a hotel room in Paris, and then think about how many hours and how many miles you'll be wearing your pack.

You should try to carry no more than twenty pounds (around 9 kg), including your pack. Remember, a good pack itself can weigh around five pounds (around 2.3 kg), and water is the single heaviest item you carry, weighing three pounds (1.35 kg) for one 1½ liter water bottle. This should be considered as part of your overall weight.

On most days, you can get by with one 1½ liter bottle of water. Carry another empty 1½ liter bottle to fill only on the warmer days (another three pounds or 1.35 kg). Carry neither more nor less water than you need. With long-term hiking, every pound makes a difference. This is why you shouldn't carry pocket knives with rarely used items, metal flashlights, or books. Don't be deceived by day hikes at home.

One pilgrim I knew, in order to save weight, carried no bar soap, no shampoo, no deodorant, and no laundry soap. While the experience *was* medieval, it's not one I recommend. Begin

and end each day as clean as if you were at home; there is plenty of time to get dirty, sweaty, and stained in between. The wise pilgrim compromises in this way: for items such as bar soap, shampoo, deodorant, laundry soap, and toothpaste, estimate what you think you will need, add just a bit more, and get rid of the rest. You don't need the extra weight, and things like these are among the heaviest a pilgrim carries. Also, it's very easy to pick up any of them along the way if you need them.

When loading your pack, put the heaviest items (for example, your poncho, if you bring one) near the top and toward the body; placing the weight up and in brings it more into alignment with the anatomy of the body and so puts it in a better position for carrying and for balance. Conversely, lighter things (for example, lighter clothing) are best packed toward the bottom and away from the body. At the same time, you do want to keep anything you might need along the trail near the top, within reach (your windbreaker, for example). Upper side pockets work well for your two $1\frac{1}{2}$ liter water bottles (which you often want to reach without taking your pack off while walking); I used the lower side pockets for lunch and snacks. Everything should be balanced relative to left and right. Be sure to newly adjust the shoulder straps, load lifter straps, and waistbelt each time you put the pack on throughout the day.

Should you bring a camera? The camera helps some people focus attention on their surroundings. For others, it acts as an invisible wall that distances the pilgrim from what he or she is experiencing and turns the participant into an observer. Act according to your own nature. If you do take a camera, however, take the smallest, lightest one you can find. Buy film as you travel and mail it home (with film mailers) rather than carrying it. The new digital cameras seem to work pretty well for this type of photography.

Those who take more than is listed below will eventually

be glad to know that French and Spanish post offices sell boxes that can be used for mailing extra weight home. If you need anything mailed to you, use general delivery (*poste restante* in France, *lista de correos* in Spain). Some guides give addresses for post offices in the towns along the way; otherwise, choose a place that is small but not too small.

CLOTHES

- ⇥ light cotton hat (with a good visor for sun and rain; a waterproof or heavier hat will be too warm)
- ⇥ hiking boots (see the important discussion on this on p. 115)
- ⇥ 1 pair cotton hiking shorts
- ⇥ 1 pair long pants (normally worn only when shorts are being washed and dried, though it may be cold every once in a while; take lightweight Supplex nylon pants, not jeans)
- ⇥ 3 cotton T-shirts (two for hiking, one for sleeping)
- ⇥ 3 pairs of cotton underwear (two for hiking, one for sleeping; the new athletic knit type with short legs prevents chafing—I saw a whole group drop out because one member developed bad chafing)
- ⇥ 2 or 3 pairs of boot socks (preferably a wool, nylon, and Lycra blend; two pairs will work just fine if you don't lose any; I recommend taking a third pair, just in case)
- ⇥ poly fleece sweater (with a fully zippered front)
- ⇥ hooded windbreaker (Supplex nylon or Gore-Tex, with a fully zippered front; see p. 117 on this)

If you think you might not have the discipline to wash every single day, take one more set of T-shirt, underwear, and socks.

EQUIPMENT

- ⇥ pack (see the important discussion on this on p. 118)
- ⇥ walking stick (an absolute necessity for fighting off dogs, get-

ting through pools of mud, making it up the hill, making it down
the hill, etc.; there's no need to get anything expensive—most
people simply pick up a likely stick along the side of the trail)

→ scallop shell (fixed to hang around the neck; very important)

→ sleeping bag (light, for warm weather; this will be used for bed-
ding in most *gîtes* and all *refugios*)

→ a 1½ liter bottle of water (buy it there; keep an empty second
one to be filled only for the warmest days; a proper canteen is
not necessary and may add weight)

→ small towel (gym towel size)

→ toiletries

· *tooth brush*

· *tooth paste (only the amount needed)*

· *dental floss (your dentist would want you to)*

· *bar soap (short-term pilgrims: only the amount needed)*

· *shampoo (only the amount needed)*

· *deodorant (short-term pilgrims: only the amount needed)*

· *concentrated laundry soap for travelers (use a non-detergent
type to protect synthetics; short-term pilgrims: only the amount
needed)*

· *lip balm (very important)*

· *a small amount of toilet paper in a small plastic bag (card-
board roll discarded)*

· *comb*

· *nail clippers (very important; see p. 113 on this)*

· *razor, if used (take as few light, disposable razors as possible;
use with bar soap)*

· *small, light scissors (moustache scissors; for cutting moleskin
and Second Skin)*

· *1 package of moleskin (for use before things get bad; see
p. 113 on this)*

· *1 package of Second Skin (for use after things get bad; see
p. 113 on this)*

· *10–15 adhesive bandages (sticking plasters) (half small, half large)*

· *a safety pin and a book of matches (for blisters; keep the safety pin pinned somewhere secure)*

➤ pocket knife (a light knife with only one or two blades is best; the largest blade should be around 2½ to 3 inches or 6 to 8 cm. The Victorinox "Classic"—which has one blade, scissors, and very little else—is ideal.)

➤ small plastic spoon (if you plan to eat something like yogurt for breakfast or lunch)

➤ waterproofer for boots (Biwell is a good brand; take only the amount needed)

➤ a pen whose ink won't run when wet (most ball points)

➤ passport

➤ pilgrim's guide (avoid any other maps or guides)

➤ pilgrim's card (see p. 109 on this)

➤ credit card and ATM card (you may need both, as I did; before leaving, confirm at your bank that they both work in the ATMs in Europe)

➤ phone cards for France and Spain (buy there)

OPTIONAL

➤ sunglasses (the route is beautiful; be sure to have color-corrected lenses, which most good sunglasses have)

➤ penlight-size flashlight (one that takes only a single AA battery and is made of a light material, not metal, is best)

➤ I bought a modest, waterproof digital wristwatch with an alarm specifically for the trip and was very glad I did

➤ broad-spectrum, high-SPF sunblock with UVA protection (only the amount needed)

➤ 15 feet (around 5 m) of thin, light cord for use as a clothesline; along with 6 clothespins (more than anything else, this seems to be the first thing that most pilgrims regret not having brought)

- a needle and a few yards of strong, dark thread taped up in a small piece of folded cardboard
- small tube of antibiotic ointment (only the amount needed)
- poncho (see p. 117 on this)
- very light after-hiking sandals (or, if you can find any, very light shoes; I took the lightest possible sandals, the kind that kids sometimes wear during the summer and that are often sold at drug stores for a dollar or two; I wouldn't recommend anything heavier)
- a small notebook for writing (one without heavy covers)
- neoprene knee braces, if you need them
- camera (see p. 119 on this)
- if you want to bring clothes for after the pilgrimage, leave them at your hotel in Paris or whatever city you were in before leaving for Le Puy
- ibuprofen (maximum recommended dose—it worked for me!)

AVOID
- an overly large pack
- an internal frame pack
- if you are a long-term pilgrim, boots heavier or lighter than medium weight, and with soles other than stiff
- heavy coats or sweaters
- clothes made from denim
- shaving cream (bar soap works just fine)
- any more than you'll need of anything (such as full bottles of shampoo or sunblock; dump out what you think you won't be needing)
- pocket knives with more than one or two blades (not counting scissors)
- a flashlight made of metal or with more than one AA battery
- reading material such as books and guides (other than your pilgrim's guide, of course)

- maps other than those in your pilgrim's guide
- heavy cameras

A personal recommendation: leave the cell phone and CD player at home. There's plenty of time for them when you get back.

Suggested Reading

It would be a big mistake to do the pilgrimage without also doing as much background reading as feels right for each individual. The first chapter of this book gives some historical background on the pilgrimage from the angle of the experience of the medieval pilgrim. The second chapter discusses the experience of the modern, long-term pilgrim. For those prospective pilgrims who want to learn more, let me warn you that the number of books and articles on the pilgrimage is vast and ranges from the academic to the ridiculous. Here I present a few fairly accessible books and articles that might interest the modern pilgrim. There are undoubtedly many other books and articles just as good that don't appear here. Extensive listings may be found in the annotated bibliographies by Davidson and Dunn listed below.

Many of these books are either out of print or unlikely to be found at your neighborhood bookstore. If your best local library doesn't have what you want, ask the librarian to get it for you on interlibrary loan—it's very easy to do. For those who want their own copy of any of these that are in print, most can be ordered through a bookstore or Internet site.

ANNOTATED BIBLIOGRAPHIES

...

Davidson, Linda Kay, and Maryjane Dunn-Wood. *Pilgrimage in the Middle Ages: A Research Guide.* New York: Garland, 1993.
On pilgrimage in general.

Dunn, Maryjane, and Linda Kay Davidson. *The Pilgrimage to Santiago de Compostela: A Comprehensive, Annotated Bibliography.* New York: Garland, 1994.

On the pilgrimage to Santiago in particular.

GENERAL

Davies, Horton, and Marie-Hélène Davies. *Holy Days and Holidays: The Medieval Pilgrimage to Compostela.* Lewisburg, Pa.: Bucknell University Press, 1982.

Representative of the better-informed accounts of the pilgrimage to Santiago written for a general audience.

Fletcher, R. A. *Saint James's Catapult: The Life and Times of Diego Gelmírez of Santiago de Compostela.* Oxford: Clarendon Press; New York: Oxford University Press, 1984.

A biography of one of the most venal, grasping, and ambitious bishops of the Middle Ages and the bishop (later archbishop) under whom the existing Romanesque cathedral was built. Only for those who are very serious about history. You'll never look at the cathedral of Santiago in the same way.

Frey, Nancy Louise. *Pilgrim Stories: On and Off the Road to Santiago.* Berkeley: University of California Press, 1998.

The best analytical and anthropological account of which I'm aware.

Gitlitz, David M., and Linda Kay Davidson. *The Pilgrimage Road to Santiago: The Complete Cultural Handbook.* New York: St. Martin's Griffin, 2000.

What can I say about this unusually useful book, one that includes information on the art, architecture, geology, history, folklore, saints' lives, and flora and fauna of the entire Spanish segment of the pilgrimage route, all in itinerary order? This is the book every pilgrim should have at hand to read every kilometer of the way—but any book, besides your guide, is too heavy to carry. So read it, take a page or two of notes on the most special of those things that appeal to you most, and carry these very brief

notes with you. Maybe some day Gitlitz and Davidson will do for the Le Puy to Saint-Jean-Pied-de-Port route what they have done for Spain.

Hell, Vera, and Hellmut Hell. *The Great Pilgrimage of the Middle Ages: The Road to St. James of Compostela.* New York: C. N. Potter, 1966.

Like the Davies book, well informed and for a general audience; very well illustrated for its time.

Moralejo, Serafín. "On the Road: The Camino de Santiago." In *The Art of Medieval Spain,* A.D. 500–1200. New York: Metropolitan Museum of Art, 1993.

Perhaps the best short introduction in English on the art of the medieval pilgrimage roads.

Nolan, Mary Lee, and Sidney Nolan. *Christian Pilgrimage in Modern Western Europe.* Chapel Hill: University of North Carolina Press, 1989.

A serious study of the pilgrimage in Europe today.

Sumption, Jonathan. *Pilgrimage: An Image of Mediaeval Religion.* London: Faber and Faber, 1975.

A general survey of pilgrimage in the Middle Ages. Those who have a strong interest in history will like this.

Tate, Brian, and Marcus Tate. *The Pilgrim Route to Santiago.* Oxford: Phaidon, 1987.

For those who prefer less emphasis on text and more emphasis on illustrations (largely color).

Turner, Victor, and Edith Turner. *Image and Pilgrimage in Christian Culture: Anthropological Perspectives.* New York: Columbia University Press, 1978.

For former college anthropology majors or those who can't just relax and have a good time. If you like this, you'll love the critique of it in the introduction to John Eade and Michael J. Sallnow, eds., Contesting the Sacred: The Anthropology of Christian Pilgrimage *(London and New York: Routledge, 1991).*

Hitt, Jack. *Off the Road: A Modern-Day Walk down the Pilgrim's Route into Spain.* New York: Simon and Schuster, 1994.

Although Hitt's primary interest seems to be to criticize people he met on the pilgrimage and didn't like, his account does give the most accurate description of everyday life of pilgrims on the Camino. Covers only the Spanish segment of the route.

Mullins, Edwin. *The Pilgrimage to Santiago.* London: Secker and Warburg, 1974.

Part history and part car-travel account.

Stanton, Edward F. *Road of Stars to Santiago.* Lexington: University Press of Kentucky, 1994.

A more reflective account than Hitt's, but also less in sync with the refugio experience that is part of the soul of the pilgrimage. Covers only the Spanish segment of the route.

Starkie, Walter. *The Road to Santiago: Pilgrims of St. James.* Berkeley: University of California Press, 1965.

Though Professor Starkie was a great raconteur and this part history, part firsthand account seems to be the most popular description of the pilgrimage, I find it completely out of spirit with the pilgrimage. Starkie walked very little of the route. Covers only the Spanish segment of the route.

MEDIEVAL SOURCES

The Book of Sainte Foy. Translated and with an introduction and notes by Pamela Sheingorn. Philadelphia: University of Pennsylvania Press, 1995.

Want to try to read a medieval Book of Miracles? You can't do better than this, though be forewarned that such a book was not written with the expectation that it would be read cover to cover as most books today are. Book One (what we would call chapter one) is classic: read this, or look

at the chapter titles (section titles) of the different miracles and read what appeals most to you.

The Pilgrim's Guide. In *The Pilgrim's Guide to Santiago de Compostela: A Gazetteer.* Edited and translated by Annie Shaver-Crandell and Paula Gerson, with the assistance of Alison Stones. London: Harvey Miller, 1995.

This is a translation of the original Latin guide for the pilgrimage to Santiago. Written in the twelfth century at the height of the pilgrimage, most nonacademic readers might find it a bit confusing — but read it anyway. Other translations are also available. If your local library doesn't have this, which is likely, have them order one for you on interlibrary loan: it's short (only thirty-two pages in this translation) and will get you into the spirit of the whole thing.

The Poem of the Cid. Translated by Lesley Byrd Simpson. Berkeley: University of California Press, 1968.

El Cid came from the area of Burgos, through which the pilgrimage route passes. This epic poem about him, far more fun to read than The Song of Roland, *was sung all along the route during the Middle Ages and will certainly help you to mentally recreate the popular atmosphere of the medieval pilgrimage.*

The Song of Roland. Translated by C. K. Scott Moncrieff. Ann Arbor: University of Michigan Press, 1959.

This is the most famous work of medieval literature associated with the pilgrimage to Santiago. Any translation will do, although this one is particularly admired for retaining the rhythm of the original. The genre of writing to which it belongs is probably more stilted than most modern readers would prefer. Read it anyway. You'll be glad you did when you are crossing the Pyrenees.

GUIDES

See the discussion on guides under "Getting There," pp. 106–109.

Organizations

These are secular organizations whose purpose is to promote the pilgrimage. It would be hard to overstate their helpfulness and selflessness. Membership is not limited to certain nationalities, nor is it required for any aspect of the pilgrimage. Most of these organizations have newsletters and Web sites that keep members informed of developments along the trail: improvements, publications, politics, and so on. The Web sites are part of "the renaissance of the pilgrimage," as described by one lover of history, and nothing makes clearer how the pilgrimage has kept pace with modern times.

AMERICAN
Friends of the Road to Santiago
Linda Davidson
2501 Kingston Rd.
Kingston, RI 02881
USA

The Friends of the Road to Santiago is increasingly expanding and establishing itself as the leading source of information on the pilgrimage in the United States today. Its membership dues are very low; join it if you are even thinking about doing the pilgrimage. Very good Web site, including suggestions for reading and a message board: www.geocities.com/friends_usa_santiago/

BRITISH
The Confraternity of Saint James
27 Blackfriars Road
London SE1 8NY
United Kingdom

The Confraternity of Saint James is a model for pilgrims' organizations outside Spain. It is very active, and has restored and runs Rabanal del Camino,

one of the most charming of all the refugios *of the pilgrimage route. The Con-fraternity deserves special praise for its publication program. Very comprehensive Web site, including an excellent selection of links to other pilgrimage Web sites and a very useful online bookstore: www.csj.org.uk*

CANADIAN

The Little Company of Pilgrims

The Canadian Little Company of Pilgrims is fairly recent. Web site: http://www.santiago.ca/

FRENCH

Société Française des Amis de Saint-Jacques de Compostelle
Centre d'Études Compostellanes
4 Square du Pont de Sèvres
92100 Boulogne-sur-Seine
France

The Société Française des Amis de Saint-Jacques de Compostelle is quite lively, even holding conferences from time to time. Web site: www.compostelle .asso.fr/

SPANISH

Federación Española de Asociaciones del Amigos
del Camino de Santiago
Calle Ruavieja 3, bajo
26001-Logroño (La Rioja)
Spain

These are the people who have done so much so well to organize, build, and maintain the pilgrimage and the refugio *system in Spain. All pilgrims to Santiago are deeply indebted to them. Web site: http://www.camino santiago.org/*

The Archdiocese of Santiago

>*Web site: http://www3.planalfa.es/arzsantiago/; clicking on "Acceso a la página para Peregrinos" will lead you to an English-language site on the pilgrimage.*

O Cebreiro Web cam

>*It is an odd view they chose for this mountain crossing with its beautiful church and former monastery, but that doesn't lessen the interest: see it in the rain and the snow, look at the beautiful sunsets, watch the pilgrims arrive and leave. But be forewarned that the live feed is sometimes turned off and a still image shown, despite what the screen says. Web site: http://www.crtvg.es/ingles/camweb/ccebreiro.html*

Santiago Cathedral Web cam

>*Three cameras outside (two of them roaming) and two inside cover the cathedral twenty-four hours a day. Watch the great celebrations surrounding the feast day of Saint James (July 25) and see if you can catch the ritual of the* botafumiero. *Web site: http://www.crtvg.es/ingles/camweb/primenucamarasflash.htm*

Finisterre Web cam

>*This is it: the End of the World. Web site: http://www.crtvg.es/ingles/camweb/primenucamarasflash.htm*